THE SHAPE OF CONTENT

The Charles Eliot Norton Lectures
1956–1957

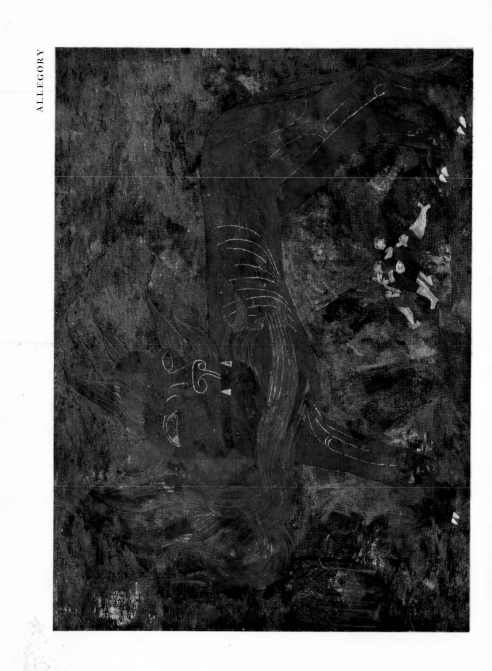

THE SHAPE OF
CONTENT

BY BEN SHAHN

HARVARD UNIVERSITY PRESS

Cambridge, Massachusetts

1957

704

CONTENTS

ACKNOWLEDGMENTS

Grateful acknowledgment is made to the W. W. Norton Company, Insel-Verlag, and The Hogarth Press, Ltd., for permission to reprint the passage from *The Notebooks of Malte Laurids Brigge* by Rainer Maria Rilke, and to Harvard University for permission to reprint passages from *Report of the Committee on the Visual Arts at Harvard University*.

Acknowledgment is gratefully made also for assistance in reproducing the drawings in *The Shape of Content* to the following: for the frontispiece, to the owner, William Bomar, Jr., of Fort Worth, Texas, and to Henry B. Caldwell of the Fort Worth Art Center and Richard Underwood of the University of Texas Press for their aid in photographing the original painting; for the drawing on page 3, to the owner, The Downtown Gallery; on pages 7, 27, 29, 33, and 112, to *Harper's Magazine;* on pages 15, 56, and 64, originally published in 1954 in *The Alphabet of Creation* by Ben Shahn, to Pantheon Books, Inc.; on page 20, to the owner, John McAndrew; on pages 27, 29, and 33, to the owner, Leon M. Despres; on pages 30 and 31, to the Estate of Curt Valentin; on pages 37 and 46, to the owner, The William Hayes Fogg Art Museum; on pages 37 and 86, to *The Nation;* on pages 41 and 54, to *Charm Magazine;* on page 42, to the owner, The Downtown Gallery, and to the Columbia Broadcasting System, Inc.; on page 71, to be published in the 1957 Christmas booklet, *Love and Joy*, to the Museum of Modern Art; on pages 80 and 81, originally published in 1956 in *Thirteen Poems of Wilfred Owen*, to The Gehenna Press; on page 116, to Erich Kahler; on page 119, to Columbia Records. The drawings on pages 7, 10, 30–31, 41, 54, 59, 69, 71, 75, 80–81, 86, 90, 94, 100, 104, 112, 116, 119, 124, 127, 129, and 131 are from the artist's collection.

The Shape of Content

Artists in Colleges

I have come to Harvard with some very serious doubts as to whether I ought to be here at all.

I am a painter; I am not a lecturer about art nor a scholar of art. It is my chosen role to paint pictures, not to talk about them.

What can any artist bring to the general knowledge or the theoretical view of art that has not already been fully expounded? What can he say in words that he could not far more skillfully present in pictorial form? Is not the painting rather than the printed page his testament? Will he not only expend his energies without in any way increasing the general enlightenment? And then, what can an audience gain from listening to an artist that it could not apprehend far more readily simply by looking at his pictures?

Here are a few of the honest questions, and I have tried to meet them with honest answers.

Perhaps the most pertinent of the questions has been as to just what I can accomplish by such a verbal Odyssey as this series of discussions promises to be. My personal answer has been that the need to formulate clearly those things which I think I think may be

I

of some value to me, and that the process will be interesting. But what about you?

From the point of view of both the audience and the university I can only suggest that the venture will probably prove about as worthy as the ideas will be good.

But there is a further reason for my being particularly interested in being here, and undertaking some such discussions. Within the past few years there has developed an increased interest in art within the universities with the promise—the possibility at least—that they may come to constitute the new art community. Such a prospect has so much to recommend it, so much in the way of intellectual stimulation for art, in the way of values and perhaps of sympathetic climate, that one hopes it may be realized.

At the same time, there is always the possibility that art may be utterly stifled within the university atmosphere, that the creative impulse may be wholly obliterated by the pre-eminence of criticism and scholarship. Nor is there perfect unanimity on the part of the university itself as to whether the presence of artists will be salutary within its community, or whether indeed art itself is a good solid intellectual pursuit and therefore a proper university study.

Such questions have been the subject of extensive conferring and surveying within the past few years, of changing attitudes on the part of the colleges and of heated disagreement; for the whole problem of creativity often reaches into basic educational philosophy, and sometimes into university policy itself.

I have a number of observations to make on this possible forthcoming alignment. They are not all of them optimistic, but they are based upon considerable familiarity on my part with the art-university relationship in process. They are made in the hope that something really fruitful may emerge and that some of the existing misconceptions and maladjustments may be erased. They are made particularly in the hope that the student who happens to be a young person of talent and ability in art may no longer be caught

2

between two impossible choices; the one whether to gain a liberal education at the cost of losing his creative habit, the other to sacrifice his liberal education in order to gain an adequate training in art.

But let us ask what possible interest the university as such can have in art? In what way can art possibly augment its perspective?

There is first the question of the educated man; and then I think there is the rather flat fact of which we are all most uncomfortably aware, that our average university graduate emerges from his years of study as something less than an educated man or woman. He is likely to be most strikingly wanting in the accomplishment of perceptivity, in the noncurricular attributes of sensitiveness and of consideration toward all those finer arts which are generally conceded to have played a great part in the humanizing of man. And our graduate is not unlikely to display total blindness with regard to painting itself.

Nowhere do his limitations become so conspicuous as in his contacts with Europeans of similar background and education. For the European, whatever his shortcomings in other directions, will be perfectly conversant with the art and literature of his own country as well as with that of others. It is not at all improbable that he will know considerably more about American art than will the American himself. Today, in view of our increasing commerce with European countries, this art-blindness of ours tends to become not just a cultural gap, but even something of a diplomatic hazard.

François Mauriac has said of us: "It is not what separates the United States from the Soviet Union that should frighten us, but what they have in common . . . those two technocracies that think themselves antagonists, are dragging humanity in the same direction of de-humanization . . . man is treated as a means and no longer as an end—this is the indispensable condition of the two cultures that face each other."

Jean-Paul Sartre has said, "If France allows itself to be influenced by the whole of American culture, a living and livable situation there will come here and completely shatter our cultural traditions . . ."

In England, V. S. Pritchett wrote of us, "Why they should not

4

be originally creative is puzzling. It is possible that the lack of the organic sense, the conviction that man is a machine—turns them into technicians and cuts them off from the chaos, the accidents and intuitions of the creative process?"

I do not agree with any one of these opinions, but I believe that they do serve to demonstrate the uneasy view that is taken of us by a few very eminent Europeans.

But that uneasy view is not confined to European countries. There have arisen some complaints on the domestic scene also, and some from very unexpected sources. A leading executive, for instance, of one of our really vast industries undertook a circuit through a number of American universities a year or so ago with only this in view: to persuade the colleges to do a better job of educating their graduates. He asked that the liberal arts be re-emphasized; he pointed out that, while technical, scientific, and other specialized training has been very advanced, there has been lacking a quality of imagination, a human view of things, which is as necessary to industry and business as is technical training.

I think that many universities today are seeking to counteract such overemphasis upon technological education and are beginning to re-emphasize liberal education. I note a great increase, at least I think I do, in serious theater, in exhibitions of painting and sculpture, in the loan of art to students, in publications of diverse sorts, but of a serious nature. I think all this activity represents an intelligent effort to place the student in a cultured and creative environment rather than to inject culture into him hypodermically, so to speak, via the specific, required, and necessarily limited classroom course.

Besides the practical objective of producing a better-educated graduate, one who may meet the new need for the international citizen, the university has other possible objectives in extending its hand toward art, these both philosophical and generous.

It has become obvious that art itself in America is without what

5

might be called a natural environment. Art and artists often exist within a public climate that is either indifferent or hostile to their profession. Or otherwise they may concentrate within small colonies wherein they find a sort of self-protection and self-affirmation. The art colonies are severely limited in the variety of experience and opinion which they can contribute to art. They become almost monastic in the degree of their withdrawal from common society; and thus their art product becomes increasingly ingrown, tapping less and less the vital streams of common experience, rejecting more and more the human imperatives which have propelled and inspired art in past times. By bringing art into the circle of humanistic studies, some of the universities consciously intend to provide for it a sympathetic climate, and one in which there will naturally be found sources of stimulation, of lore, of intellectual material, and even of that element of controversy on which art thrives so well.

Philosophically, I daresay such a policy will be an item in the general objective of unifying the different branches of study toward some kind of a whole culture. I think that it is highly desirable that such diverse fields as, let us say, physics, or mathematics, come within the purview of the painter, who may amazingly enough find in them impressive visual elements or principles. I think that it is equally desirable that the physicist or mathematician come to accept into his hierarchy of calculable things that nonmeasurable and extremely random human element which we commonly associate only with poetry or art. Perhaps we may move again toward that antique and outmoded ideal—the whole man.

Such, I think, is the university's view and objective in embracing the arts however cautiously it may proceed. But the artist's view must also be considered and the question of whether the university will become his natural habitat, or will spell his doom. This highly debatable point has its implications for all the creative arts within the university, as well as for the artist-teacher, the artist-in-

6

residence, and by all means, the artist-student.

The first observation to be made here is the rather obvious one that art has its roots in real life. Art may affirm its life-giving soil or repudiate it wholly. It may mock as bitterly as did Goya, be partisan, as was Daumier, discover beauty within the sordid and real as did Toulouse-Lautrec. Art may luxuriate in life positively and affirmatively with Renoir, or Matisse, or Rubens, or Vermeer. It may turn to the nebulous horizons of sense-experience with the Post-Impressionists, the Cubists, the various orders of Abstraction-

7

ist, but in any case it is life itself as it chances to exist that furnishes the stimulus for art.

That is not to say any special branch or section of life. Any living situation in which an artist finds material pertinent to his own temper is a proper situation for art. It would not have made sense for Paul Klee to have followed the boxing circuit nor for George Bellows to have chased the vague creatures that lurk within lines and squares or to have pursued the innuendoes of accidental forms which yielded so much treasure to Klee. Yet each of these artists found in such casual aspects of reality a form of life, a means to create an *oeuvre*, to build a language of himself, his peculiar wit and skill and taste and comprehension of things.

While I concede that almost every situation has its potential artist, that someone will find matter for imagery almost anywhere, I am generally mistrustful of contrived situations, that is, situations peculiarly set up to favor the blossoming of art. I feel that they may vitiate the sense of independence which is present to some degree in all art. One wonders how the Fauves would have fared without the Bourgeoisie, how Cézanne would have progressed if he had been cordially embraced by the Academy. I am plagued by an exasperating notion: What if Goya, for instance, had been granted a Guggenheim, and then, completing that, had stepped into a respectable and cozy teaching job in some small—but advanced!— New England college, and had thus been spared the agonies of the Spanish Insurrection? The unavoidable conclusion is that we would never have had "Los Caprichos" or "Los Desastres de la Guerra." The world would not have been called upon to mourn for the tortured woman of the drawing inscribed "Because She Was a Liberal!" Nor would it have been stirred by Goya's pained cry, "Everywhere It Is The Same!" Neither would it have been shocked by his cruel depictions of human bestiality, nor warned—so graphically, so unforgettably—that fanaticism is man's most abominable trait.

Thus it is not unimaginable that art arises from something

8

stronger than stimulation or even inspiration—that it may take fire from something closer to provocation, that it may not just turn to life, but that it may at certain times be compelled by life. Art almost always has its ingredient of impudence, its flouting of established authority, so that it may substitute its own authority, and its own enlightenment.

How many ponderous tracts have been written upon those drips and threads of paint by which the late Jackson Pollock made himself known! If his peculiar decor has its human dimension, that does not lie within the time-space, the interplanetary meanings so often ascribed to the work, but rather in the impudence of setting forth such work; the boldness of recognizing the beauty which does reside in such a surface; the executing of it, the insistence upon presenting such effects as art. I doubt whether, in a completely benign atmosphere, such an art as Pollock's would have been born; whether it would have produced the degree of shock and opposition which may well have been one of the most stimulating factors in its growth.

So I believe that if the university's fostering of art is only kindly, is only altruistic, it may prove to be also meaningless. If, on the other hand, the creative arts, the branches of art scholarship, the various departments of art are to be recognized as an essential part of education, a part without which the individual will be deemed less than educated, then I suppose that art and the arts will feel that degree of independence essential to them; that they will accept it as their role to create freely—to comment, to outrage, perhaps, to be fully visionary and exploratory as is their nature.

Art should be well-subsidized, yes. But the purchase of a completed painting or a sculpture, the commissioning of a mural—or perhaps the publication of a poem or a novel or the production of a play—all these forms of recognition are the rewards of mature work. They are not to be confused with the setting up of something not unlike a nursery school in which the artist may be

9

spared any conflict, any need to strive quite intently toward command of his medium and his images; in which he may be spared even the need to make desperate choices among his own values and his wants, the need to reject many seeming benefits or wishes. For it is through such conflicts that his values·become sharpened; perhaps it is only through such conflicts that he comes to know himself at all.

It is only within the context of real life that an artist (or anyone) is forced to make such choices. And it is only against a back-

ground of hard reality that choices count, that they affect a life, and carry with them that degree of belief and dedication and, I think I can say, spiritual energy, that is a primary force in art. I do not know whether that degree of intensity can exist within the university; it is one of the problems which an artist must consider if he is to live there or work there.

So the answers to the question—Is it possible for an artist to function fully within the university?—must be a series of provisional ones.

Ideally, yes, for as an intellectual center, the university can provide background and stimulation to the artist; it can broaden him as an individual; it can conceivably provide new directions for art. All this, if one accepts the thesis that art is an intellectual as well as an emotional process, and that it thus profits by an expanded range of knowledge and experience.

Ideally, yes, for art scholarship itself should provide continuity and perspective for the artist, should enrich his imagery, should in every way complement the creative process by the scholarly one.

Ideally, yes, the artist ought to function well within the university community for it seems desirable that the one-sidedness of the educational pattern be counteracted, and in this sense art has a mission to perform as well as an advantage to gain. Yes, too, because within the university art may become familiar to, and accepted by, those young people who will probably constitute the taste-makers of tomorrow, the intellectual leadership, the future audience of art.

Thus, ideally we may conclude that the university holds great promise for art. Factually, however, there are circumstances which render the prospects less optimistic.

One such circumstance is the record itself of artists who have lived in residence or taught in the universities over a number of years. In the report issued in 1956 by the Committee on the Visual

Arts at Harvard University we read the following well-considered lines:

In too many cases, unfortunately, the artist-teacher gradually develops into something else: the teacher who was formerly an artist. Too often the initial basis of appointment was fallacious. In the desire to find an artist who would "get along" with art historians, the department acquired a colleague who got along well enough but turned out to be neither much of an artist nor much of a teacher. Few artists [the report continues] are sufficiently dedicated to teaching to make a career of it. Over a long time, the danger is that the artist will produce less and less art while still preserving the attitude that his teaching is of secondary importance to it.

In support of this observation, I will recount a few instances: I have one friend who has been artist-in-residence at a great Western university for some years. He is well paid. When I first knew him he was a bright light in American art, one of the good names. Full of vigor, imagination, and daring—and good thinking too—he was then producing one impressive canvas after another, and he was beginning to be sought after by collectors and museums. Today he is painting small decorative vignettes, I cannot understand why. One cannot help but observe that his work today reflects what must be polite good taste—a sort of decorator taste—in the small city in which the university is situated. The university itself seems to have absorbed very little of this man's influence. On the walls of his fine studio there still hang a number of his large earlier canvases, a sort of indecorous reminder that he was once a brash and bold young painter.

Such a change may certainly take place in a man for a number of reasons and under all sorts of circumstances, and it would be unfair to attribute it to the academic situation were it not for other similar instances.

I can at the moment recall three other artists each of whom has

formerly been prominent in the gallery world. Each is now a university professor, the head of his department, and each is now primarily an administrator and teacher. And in addition to his administrative and teaching work, he undertakes a certain round of promotional duties which seem to us on the outside peculiarly unfitting for an artist. Two of these men have disappeared completely from the gallery world, and I have not seen a picture from the third—to my mind a great artist—for several years.

With all this before me it is small wonder that I have had misgivings as to whether my own present undertaking is a right one. (Actually, I am not very deeply concerned about my own persistence in remaining a painter.) My real concern is for the whole prospect of the artist within the university, for increasingly, and whether for good or ill, the artist is becoming a familiar figure within the university environs. The question of his ability to survive as an artist is not, we might say, wholly academic.

On the basis of fairly extensive observation I have concluded that there are about three major blocks to the development of a mature art, and to the artist's continuing to produce serious work within the university situation. And perhaps these major blocks may reach beyond the field of art.

The first of them is dilettantism. Dilettantism, as we all know, is the nonserious dabbling within a presumably serious field by persons who are ill-equipped—and actually do not even want—to meet even the minimum standards of that field, or study, or practice. Dilettantism in the university is best observed in the so-called "smattering" courses themselves, but it is by no means confined to such academic routine; it is a fairly pervasive attitude.

I understand fully the need to educate broadly. And I understand and applaud that breadth of interest that impels the bright human being to dip into or to investigate all sorts of divergent fields. Obviously there is a contradiction here. For to have a broad ac-

quaintance with a number of different studies means that at least some of these studies cannot be met on a professional level.

I think that the university has met the contradiction fairly successfully in some fields, but has certainly not done so in the field of art. For in this field, dilettantism governs the whole departmental attitude, whereas in other fields of study the department itself is regarded seriously, however little may be absorbed by the student whose main interest is elsewhere.

I believe that it is an objective of any one of the major departments within the greater universities to constitute in itself a center for its field, so that individuals and institutions in the practical world customarily look to the university for the most advanced work or opinion obtainable. Ideas and leadership then flow out of the university and into general currency. And need I cite the leadership of the universities in such fields as that of physics, of all the branches of sociology and psychology, of archaeology and numerous other fields!

In this connection, the Visual Arts Committee Report comments:

All the timidity that now surrounds the thought of bringing artist and studio into the university, on a par with other fields of scholarship, lately surrounded the same venture with regard to scientists. Just as the scientist has found his place within the university, just as his laboratory has become academically respectable, so the artist and studio, given time and opportunity, should find their places. [And the report also says] *Though research laboratories in industry and government contribute increasingly to the advancement of fundamental science, the university is still the primary source of the most important scientific progress.*

Students then—even those who do not expect to follow a particular field itself—may still derive some sense of its stature and its real meaning. And the individuals who teach and who work under

14

the university aegis are actually working in the center of their field and not on its fringe. Thus the university may be assured of gaining the foremost talent in such studies, while the teacher himself, the physicist-teacher or the sociologist-teacher, let us say, need not be disillusioned nor bored by the level at which his profession exists.

Quite the opposite is true in the field of art, that is, of creative art. In the first place the university directorship is quite likely to look somewhat askance at its art departments and its art courses as somewhat frivolous. (It is not inconceivable that the great public blind spot toward art extends even to such high places.) The student of art in a college is almost required to guard himself against becoming involved or too serious about his art. He will dabble a bit once or twice during a week, but must not and literally can not make of art a field of major interest.

He may be an art-history student, or an architecture, or an aesthetics student, in which case he will do a little painting "just," as the saying goes, "to get his hand in." Or a student may display a passionate interest in painting; but even in that event he is

still required only to play about lightly. He cannot devote either long hours or concentration to his work. The artist-teacher is thus not able to require or to expect serious work from his students—not even from the talented ones. And thus the level of the work that is produced is likely to arouse in him something akin to physical illness, particularly if he is himself an artist of great capability. And then he must perforce ask himself what he is doing there and why he is not off painting his own pictures.

I cannot understand why there should exist such mistrust of creative work. Is it to guard the student against an incautious degree of self-committal? Or is it indecision as to whether art is really a wholly decorous profession? Or is there some conflict in value as between the art that has already safely taken place, and that which —alarmingly enough—may take place?

Some such conflict appears within the Visual Arts Report itself:

[On page 10, for instance, we read] *The Committee believes that the visual arts are an integral part of the humanities and as such must assume a role of prominence in the context of higher education.* [Yet, on page 66, we find] *It is still doubtful if a student at Harvard can find space or time to apply himself seriously to creative work in the visual arts.* [On page 9, the enlightened comment] *at no moment in history since the invention of printing has man's communication with his fellow man been so largely taken over by visual media as today.* [But, on page 65, we read the following] *We do not propose to inject the art school into the academic life, but rather to give the experience of art its rightful place in liberal education.*

I wonder whether the university would also suggest offering the *experience* of calculus, of solid state physics; the experience of French or German; the experience of economics, of medieval history, of Greek.

I was one of those asked to give an opinion concerning the

desirability of the university for the education of an artist. I expressed preference for the university as against the professional art school. But my rejection of the art school was certainly not on the grounds of its professionalism; indeed that is the one thing that recommends it. My preference for the university is based upon a belief that the very content of the liberal education is a natural content of art, that art will profit by and greatly needs the content of liberal education. Further, that the humanities and the humanistic view have been the companions of art during the great periods of both.

But if dilettantism is to pervade the whole atmosphere of art, and even the very department in which it is taught, then, far from being the best influence for the young artist, the university may prove to be the worst, and may further prove equally unfavorable to the artist-teacher.

The second major block to the development of a mature art and to the artist's thriving within the university community is the fear of creativity itself. The university stresses rather the critical aspects of knowledge—the surveying, the categorizing, the analyzing, and the memorizing. The reconversion of such knowledge into living art, into original work, seems to have diminished. In a few universities—particularly in the East—discouragement of original work has achieved the status of policy. I was told by a department head in one university that in that institution the creative arts are discouraged because "it is felt that they may interfere with the liberal arts." I have never been able to understand actually what he meant, but the result of the policy is brilliantly clear, and that result is that the student misses the vital opportunity to integrate what he knows with what he thinks—that he fails to form the expressive, the creative habit.

In another university I once had occasion to pay a number of visits to its very large ceramics department. I noticed that there was

a great leafing about among books whenever a piece of pottery was to be decorated, and that not even the shapes of pieces were original. It seemed to me that the students were missing whatever pleasure there may be in the work. In talking to them, I made the odd discovery that they did not consider themselves capable of originating a decoration; it was not for them. In fact one student explained to me that that was not the course they were taking.

A very trivial incident indeed, but still a disturbing one. Could it be that the students were too impressed by the past of ceramics, by the Greek, the Chinese, the Etruscan, to be able to surmount that and create something of their own? It is not impossible that within the university the pre-eminence of scholarship itself may become an impassable block to creativity, and may over-impress and stifle both the artist-teacher and the student.

The artist who is only a painter may well become intimidated by his degree-bearing brethren. Under the charmed light of their MA's, their PhD's, their accumulated honors and designations, the scholars speak of art in terms of class and category, and under headings of which the artist may never have heard. While he himself may have read extensively about art—and I think that most artists do read a great deal about art, and know a great deal about it—while he may have looked at scores of paintings, have dwelt upon them and absorbed them, his interest has been a different one; he has absorbed visually, not verbally. The idea of classifying such work would never have occurred to him, because to him the work is unique; it exists in itself alone. It is its distinction from other art, not its commonality with other art, that interests him. If· the work has no such distinction, if it does not stand alone, he has no reason for remembering it. And yet, surrounded by abstract and learned discussion, his own vision may waver and its reality grow dim.

At the same time I feel that both art history and art theory are of immense value to the creative artist. All such material lends depth and subtlety to art, and it is definitely stimulating to most

artists. Only when, in the verbalizing or the teaching process, the original creative necessity is obliterated does art theory or art history tend to suffocate the artist.

I have a young friend who, through most of his high-school years, was given to writing poetry. He is now entering his junior year in the university. The other evening I asked him what sort of verse he had been writing, and whether I might read some of it. He replied, "Oh, I've stopped writing poetry." Then he explained, "There's so much that you have to know before you can write poetry. There are so many forms that you have to master first. Actually," he said, "I just wrote because I liked to put things down. It didn't amount to much; it was only free verse."

Perhaps my young friend would never under any circumstances have become a good poet. Perhaps he should have had the drive and persistence to master those forms which have defeated him—I myself think he should. But I wonder whether it was made clear to him that all poetic forms have derived from practice; that in the very act of writing poetry he was, however crudely, beginning to create form. I wonder whether it was pointed out to him that form is an instrument, not a tyrant; that whatever measures, rhythms, rhymes, or groupings of sounds best suited his own expressive purpose could be turned to form—possibly just his own personal form, but form; and that it too might in time take its place in the awesome hierarchy of poetic devices.

Scholarship is perhaps man's most rewarding occupation, but that scholarship which dries up its own creative sources is a *reductio ad absurdum*, a contradiction of itself.

And there is the loneliness and isolation of the artist upon the college grounds. Of course we know that many artists have painted alone with great success. But of these we may say that they chose loneliness: loneliness was their theme and their way of painting. Theirs has been a different loneliness from that of the artist who, safely cushioned within the pleasantest and most agreeable environ-

ment known to man, must at some point arise from the good con-
versational table, move off, don his paint-spattered pants, squeeze
out his tubes and become involved in the nervous, unsure, tense,
and unsatisfactory business of making a picture which will have
cohesion, impact, maturity, and an unconscionable lot of sheer
work; which will, most uncomfortably, display an indiscreet and

unveiled feeling about something; and which will then proceed to violate every canon of good art behavior just delineated by his recent companions.

These latter have no need to create something new. It is enough that they discover the old and bring it home to the common consciousness in all its radiance.

The third major block to the successful functioning of the artist within the university is a somewhat romantic misconception as to what sort of man he is. The more venerable academic element, still under the sway of Trilby, looks upon an artist as a mad genius. This group believes, and I think the public joins it, that an artist has no idea of why he paints; he simply has to. Among the younger and more advanced collegians, the New Criticism has taken over, but the artist himself fares no better. For according to this very avant-garde view, it makes little difference what an artist paints or what he himself happens to think; it is the viewer who really accounts for the meaning of the work, and even he would flounder about hopelessly were it not for the theorist, or critic. In his hands rest all the clues to art; he is the high priest of the art process.

I have one critical fencing companion who assures me that the meaning of one order of art—the nonobjective—is a supra-human, that is, a cosmic one. The artist, as he describes him, is a medium through which all sorts of ineffable forces flow. Any willing, however, on the part of the artist, any intending, would be an interference, would only destroy the time-space continuum, would render impure the art produced.

And, by implication, that art which is the product of willing and intending must be impure.

As criticism itself flourishes particularly within the universities, so does this particular critical view find its warmest advocates there. In several universities, the critical circle has formed itself into a small cultural nucleus which exerts a powerful influence, one not

free of snobbery, upon the arts—a Gorgon-like power that turns the creative artist into stone.

This curious academic mutation is corroborated within the Visual Arts Report in a most understanding passage.

It is a curious paradox that, highly as the university esteems the work of art, it tends to take a dim view of the artist as an intellectual . . . one encounters the curious view that the artist does not know what he is doing. It is widely believed and sometimes explicitly stated that the artist, however great his art, does not genuinely understand it, neither how he produced it, nor its place in the culture and in history.

At this point I cannot resist a few somewhat crisper lines in this direction from Francis Bacon: "Some there have been," says the philosopher, "who have made a passage for themselves and their own opinions by pulling down and demolishing former ones; and yet all their stir has but little advanced the matter, since their aim has been not to extend philosophy and the arts in substance and value, but only to . . . transfer the kingdom of opinion to themselves."

Before the artist can be successfully oriented within the university environment there will be needed a calmer view toward both the qualities of the man and the qualities of the work. No artist will be at ease with an opinion that holds him to be a mere handy-man of art—the fellow who puts the paint on. Nor will any artist rest well with the notion that he is a mad genius—something other than human, either more than human or less than human or tangential to human. The whole notion of genius needs to be reassessed, needs perhaps to be deglamorized somewhat. For genius is certainly much more a matter of degree than of kind. The genius so-called is only that one who discerns the pattern of things within the confusion of details a little sooner than the average man. Thus the genius (again, I insist upon saying so-called) is likely to be impatient with those

individuals who fail to discern such patterns, such larger meanings, within common affairs.

If the artist, or poet, or musician, or dramatist, or philosopher seems somewhat unorthodox in his manner and attitudes, it is because he knows—only a little earlier than the average man—that orthodoxy has destroyed a great deal of human good, whether of charity, or of good sense, or of art.

It seems to me that, far from setting the "genius" apart, the university should constitute itself the natural place toward which the young person of such exceptional talent may turn for an education suitable to his talent. Otherwise we announce, in effect, that the broadness of view, the intellectual disciplines, the knowledge content which the university affords are reserved for the unproductive man—the uncreative, the nonbrilliant. Such an assumption would be an absurdity, and yet how often do I hear voiced the sentiment that the university is not for the young person of genius.

Withal the foregoing, I do not attribute to the university an intentional undervaluing of art, nor do I believe that creativeness in other fields is discouraged by intention other than in a few conspicuous instances. In the abstract, I believe that creative art is eminent in the university hierarchy of values. But teaching itself is so largely a verbal, a classifying, process that the merely intuitive kinds of knowing, the sensing of things which escape classification, the self-identification with great moods and movements in life and art and letters may be lost or obliterated by academic routine. They are not to be taught but rather absorbed through a way of life in which intensively developed arts play an easy and familiar part. For it is just such inexact knowing that is implicit in the arts. And actually I believe that it is toward this kind of knowing that the classifications of the classroom reach, if sometimes unsuccessfully.

It is this kind of knowing also—the perceptive and the intuitive —that is the very essence of an advanced culture. The dactyl and the spondee, the heroic couplet, the strophe and the antistrophe

may be valuable and useful forms to the poet; but the meaning of the poem and its intention greatly transcend any such mechanics.

I hope, in the following discussions, to give you my view of art, of its forms and its meanings, from that particular, isolated, uncertificated promontory which I as an artist occupy, which perhaps any artist occupies. But I have thought it desirable first to locate art, artists, and the creative process itself vis-à-vis the university and *its* prevailing point of view. That I am here at all is evidence of the changing attitude toward art within the universities.

The Biography
of a Painting

In 1948, while Henry McBride was still writing for the *New York Sun*, I exhibited a painting to which I had given the somewhat cryptic title, "Allegory." The central image of the painting was one which I had been developing across a span of months—a huge Chimera-like beast, its head wreathed in flames, its body arched across the figures of four recumbent children. These latter were dressed in very commonplace clothes, perhaps not entirely contemporary, but rather as I could draw them and their details from my own memory.

I had always counted Henry McBride as a friend and an admirer of my pictures, about which he had written many kind words. Even of this one, he wrote glowingly at first. Then he launched into a strange and angry analysis of the work, attributing to it political motives, suggesting some symbolism of Red Moscow, drawing parallels which I cannot recall accurately, but only their tone of

violence, completing his essay by recommending that I, along with the Red Dean of Canterbury, be deported.

Mr. McBride's review was not the first astonishing piece of analysis of my work that I have read, nor was it the last. Perhaps, coming as it did from a critic whom I had looked upon as a friend, it was one of the most disconcerting. In any case, it caused me to undertake a review of this painting, "Allegory," to try to assess just for my own enlightenment what really was in it, what sort of things go to make up a painting. Of the immediate sources I was fully aware, but I wondered to what extent I could trace the deeper origins, and the less conscious motivations.

I had an additional reason for undertaking such an exploration besides the pique which Mr. McBride's review had engendered. I had long carried in my mind that famous critical credo of Clive Bell's, a credo which might well have been erased by time, but which instead has grown to almost tidal proportions and which still constitutes the Procrustean bed into which all art must be either stretched or shrunk. The credo runs as follows: "The representative element in a work of art may or may not be harmful, but it is always irrelevant. For to appreciate a work of art, we must bring with us nothing from life, no knowledge of its affairs and ideas, no familiarity with its emotions."

Once proffered as an isolated opinion, that view of art has now become a very dominant one, is taught in the schools, and is laboriously explained in the magazines. Thus, in reconsidering the elements which I feel have formed the painting "Allegory," I have had in mind both critical views, the one which presumes a symbolism beyond or aside from the intention of a painting, and the other, that which voids the work of art of any meaning, any emotion, or any intention.

The immediate source of the painting of the red beast was a Chicago fire in which a colored man had lost his four children. John Bartlow Martin had written a concise reportorial account of the

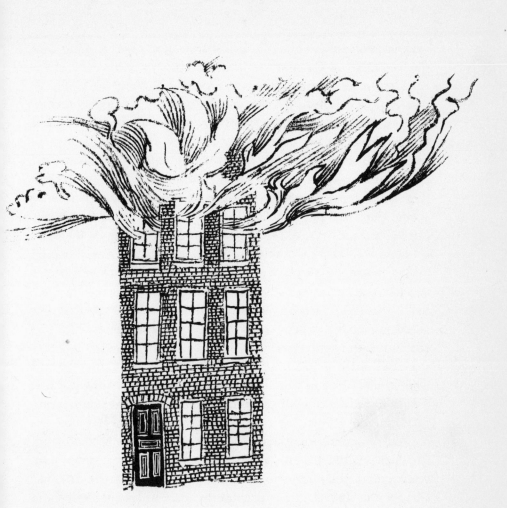

event—one of those stories which, told in detail, without any emo-
tionalism being present in the writing itself, manages to produce a
far greater emotional impact than would a highly colored account.

I was asked to make drawings for the story and, after several
discussions with the writer, felt that I had gained enough of the
feel of the situation to proceed. I examined a great deal of factual

visual material, and then I discarded all of it. It seemed to me that the implications of this event transcended the immediate story; there was a universality about man's dread of fire, and his sufferings from fire. There was a universality in the pity which such a disaster invokes. Even racial injustice, which had played its part in this event, had its overtones. And the relentless poverty which had pursued this man, and which dominated the story, had its own kind of universality.

I now began to devise symbols of an almost abstract nature, to work in terms of such symbols. Then I rejected that approach too. For in the abstracting of an idea one may lose the very intimate humanity of it, and this deep and common tragedy was above all things human. I returned then to the small family contacts, to the familiar experiences of all of us, to the furniture, the clothes, the look of ordinary people, and on that level made my bid for universality and for the compassion that I hoped and believed the narrative would arouse.

Of all the symbols which I had begun or sought to develop, I retained only one in my illustrations—a highly formalized wreath of flames with which I crowned the plain shape of the house which had burned.

Sometimes, if one is particularly satisfied with a piece of work which he has completed, he may say to himself, "well done," and go on to something else. Not in this instance, however. I found that I could not dismiss the event about which I had made drawings— the so-called "Hickman Story." In the first place, there were the half-realized, the only intimated drawings in a symbolic direction which were lying around my studio; I would develop some of them a little further to see what might come of them. In the second place there was the fire itself; I had some curious sense of responsibility about it, a sort of personal involvement. I had still not fully expressed my sense of the enormity of the Hickman fire; I had not formulated it in its full proportions; perhaps it was that I felt that

28

I owed something more to the victim himself.

One cannot, I think, crowd into drawings a really towering content of feeling. Drawings may be small intimate revelations; they may be witty or biting, they may be fragmentary glimpses of great feeling or awesome situation, but I feel that the immense idea asks for a full orchestration of color, depth, texture, and form.

The narrative of the fire had aroused in me a chain of personal memories. There were two great fires in my own childhood, one only colorful, the other disastrous and unforgettable. Of the first, I

remember only that the little Russian village in which my grand-father lived burned, and I was there. I remember the excitement, the flames breaking out everywhere, the lines of men passing buck-ets to and from the river which ran through the town, the mad-woman who had escaped from someone's house during the con-fusion, and whose face I saw, dead-white in all the reflected color.

The other fire left its mark upon me and all my family, and left its scars on my father's hands and face, for he had clambered up a drainpipe and taken each of my brothers and sisters and me out of the house one by one, burning himself painfully in the process. Meanwhile our house and all our belongings were consumed, and my parents stricken beyond their power to recover.

Among my discarded symbols pertaining to the Hickman story there were a number of heads and bodies of beasts, besides several Harpies, Furies, and other symbolic, semi-classic shapes and figures. Of one of these, a lion-like head, but still not a lion, I made many drawings, each drawing approaching more nearly some inner figure of primitive terror which I was seeking to capture. I was beginning to become most familiar with this beast-head. It was, you might say, under control.

Of the other symbols I developed into paintings a good menagerie of Harpies, of birds with human heads, of curious and indecipherable beasts all of which I enjoyed immensely, and each of which held just enough human association for me to be great fun,

and held just enough classical allusion to add a touch of elegance which I also enjoyed. (And this group of paintings in turn led off into a series of paintings of more or less classical allusion, some only pleasant, but some which like the "City of Dreadful Night" or "Homeric Struggle" were major paintings to me, each having, beside its classical allusion, a great deal of additional motivation.)

When I at last turned the lion-like beast into a painting, I felt able to imbue it with everything that I had ever felt about a fire. I incorporated the highly formalized flames from the Hickman story as a terrible wreath about its head, and under its body I placed the four child figures which, to me, hold the sense of all the helpless and the innocent.

The image that I sought to create was not one of *a* disaster; that somehow doesn't interest me. I wanted instead to create the emotional tone that surrounds disaster; you might call it the inner disaster.

In the beast as I worked upon it I recognized a number of creatures; there was something of the stare of an abnormal cat that we once owned that had devoured its own young. And then, there was the wolf.

To me, the wolf is perhaps the most paralyzingly dreadful of beasts, whether symbolic or real. Is my fear some instinctive strain out of my Russian background? I don't know. Is it merely the product of some of my mother's colorful tales about being pursued by wolves when she was with a wedding party, or again when she went alone from her village to another one nearby? Does it come from reading Gogol? Whatever its source, my sense of panic concerning the wolf is real. I sought to implant, or, better, I recognized something of that sense within my allegorical beast.

Then, to go on with the wolf image: I had always found disconcerting the familiar sculpture of Romulus and Remus being suckled by the She-Wolf. It had irritated me immensely, and was a symbol that I abhorred. Now I found that, whether by coin-

cidence or not I am unable to say, the stance of my imaginary beast was just that of the great Roman wolf, and that the children under its belly might almost be a realization of my vague fears that, instead of suckling the children, the wolf would most certainly destroy them. But the children, in their play-clothes of 1908, are not Roman, nor are they the children of the Hickman fire; they resemble much more closely my own brothers and sisters.

Such are a few of the traceable sources of imagery, and of the feeling of a single painting—mine, only because I can know what these sources are, because I am able to follow them backward at least to that point at which they disappear into the limbo of the subconscious, or the unconscious, or the instinctive, or the merely biological.

But there are many additional components present within a painting, many other factors that modify, impel, restrain, and in unison shape the images which finally emerge.

The restraining factors alone wield a powerful, albeit only negative, invisible hand. An artist at work upon a painting must be two people, not one. He must function and act as two people all the time and in several ways. On the one hand, the artist is the imaginer and the producer. But he is also the critic, and here is a critic of such inexorable standards as to have made McBride seem liberal even in his most illiberal moment.

When a painting is merely in the visionary stage, the inner critic has already begun stamping upon it. The artist is enthusiastic about some idea that he has. "You cannot," says the inner critic, "superimpose upon visual material that which is not essentially visual. Your idea is underdeveloped. You must find an image in which the feeling itself is embedded. An image of a fire? Not at all! A fire is a cheerful affair. It is full of bright colors and moving shapes; it makes everybody happy. It is not your purpose to tell about a fire, not to describe a fire. Not at all; what you want to formulate is the terror, the heart-shaking fear. Now, find that image!"

So the inward critic has stopped the painting before it has even been begun. Then, when the artist strips his idea down to emotional images alone and begins slowly, falteringly, moving toward some realization, that critic is constantly objecting, constantly chiding, holding the hand back to the image alone, so that the painting remains only that, so that it does not split into two things, one, the image, and another, the meaning.

I have never met a literary critic of painting who, whatever his sentiments toward the artist, would actually destroy an existing painting. He would regard such an act as vandalism and would never consider it. But the critic within the artist is a ruthless destroyer. He continually rejects the contradictory elements within a paint-

34

ing, the colors that do not act upon other colors and would thus constitute dead places within his work; he rejects insufficient drawing; he rejects forms and colors incompatible with the intention or mood of the piece; he rejects intention itself and mood itself often as banal or derivative. He mightily applauds the good piece of work; he cheers the successful passage; but then if the painting does not come up to his standards he casts aside everything and obliterates the whole.

The critic within the artist is prompted by taste, highly personal, experienced and exacting. He will not tolerate within a painting any element which strays very far from that taste.

During the early French-influenced part of my artistic career, I painted landscapes in a Post-Impressionist vein, pleasantly peopled with bathers, or I painted nudes, or studies of my friends. The work had a nice professional look about it, and it rested, I think, on a fairly solid academic training. It was during those years that the inner critic first began to play hara-kiri with my insides. With such ironic words as, "It has a nice professional look about it," my inward demon was prone to ridicule or tear down my work in just those terms in which I was wont to admire it.

The questions, "Is that enough? Is that all?" began to plague me. Or, "This may be art, but is it my own art?" And then I began to realize that however professional my work might appear, even however original it might be, it still did not contain the central person which, for good or ill, was myself. The whole stream of events and of thinking and changing thinking; the childhood influences that were still strong in me; my rigorous training as a lithographer with its emphasis upon craft; my several college years with the strong intention to become a biologist; summers at Woods Hole, the probing of the wonders of marine forms; all my views and notions on life and politics, all this material and much more which must constitute the substance of whatever person I was, lay outside the scope of my own painting. Yes, it was art that I was producing,

perfectly competent, but foreign to me, and the inner critic was rising up against it.

It was thus under the pressure of such inner rejection that I first began to ask myself what sort of person I really was, and what kind of art could truly coincide with that person. And to bring into this question the matter of taste I felt—or the inner critic felt—that it was both tawdry and trivial to wear the airs and the artistic dress of a society to which I did not belong.

I feel, I even know, that this first step in rejection is a presence within the fire-image painting of which I have undertaken to speak. The moving toward one's inner self is a long pilgrimage for a painter. It offers many temporary successes and high points, but there is always the residuum of incomplete realization which impels him on toward the more adequate image.

Thus there began for me the long artistic tug of war between idea and image.

At first, the danger of such a separation did not appear. For my first disquisition in paint was only semi-serious. My friend Walker Evans and I had decided to set up an exhibition in the barn of a Portuguese family on Cape Cod. He would exhibit a series of superb photographs which he had made of the family there; I would exhibit a few water colors, most of them not yet in existence.

At just that time I was absorbed in a small book which I had picked up in France, a history of the Dreyfus case. I would do some exposition of the affair in pictures. So I set to work and presented the leading malefactors of the case, the defenders, and of course Dreyfus himself. Under each portrait I lettered in my best lithographic script a long or short legend setting forth the role which the original of the portrait had played in the celebrated affair.

What had been undertaken lightly became very significant in my eyes. Within the Dreyfus pictures I could see a new avenue of expression opening up before me, a means by which I could unfold a great deal of my most personal thinking and feeling without loss

36

of simplicity. I felt that the very directness of statement of these pictures was a great virtue in itself. And I further felt, and perhaps hoped a little, that such simplicity would prove irritating to that artistic elite who had already—even at the end of the twenties—begun to hold forth "disengagement" as the first law of creation. As artists of a decade or so earlier had delighted to *épater le bourgeois,* so I found it pleasant, to borrow a line from Leonard Baskin, to *épater l'avant-garde.*

Having returned only recently from France where the Sacco-Vanzetti case was a national fever, I now turned to that noted drama for the theme of a new group of paintings, and set about revealing the acts and the persons involved with as rigorous a simplicity as I could command. I was not unmindful of Giotto, and of the simplicity with which he had been able to treat of connected

events—each complete in itself, yet all recreating the religious drama, so living a thing to him.

The ensuing series of pictures was highly rewarding to me. First, I felt that my own work was now becoming identified with my person. Then there was the kind of response which met the pictures; not only did the customary art public receive the work kindly, but there was also an entirely new kind of public, a great influx of people who do not ordinarily visit galleries—journalists and Italian immigrants and many other sorts of sympathizers. And then there was the book about the case which Benchley sent to me, inscribed, "to Ben Shahn without whom this crime could never have been committed."

I continued to work in terms of pictures which related to a central theme, the inner critic being somewhat appeased and exercising only a certain technical stringency. A new series of questions now arose for me, and with them the inevitable consequent rejections. I began to question the degree of my belief in the views which I held. It became uncomfortably apparent to me that whatever one thinks as well as whatever one paints must be constantly re-examined, torn apart, if that seems to be indicated, and reassembled in the light of new attitudes or new discovery. If one has set for himself the position that his painting shall not misconstrue his personal mode of thinking, then he must be rather unusually alert to just what he does think.

I was impelled to question the social view of man to which I had adhered for a number of years without actually doubting that it might be either a right view or a natural one to me. Now it dawned upon me that I had always been at war with this idea. Generalities and abstractions and vital statistics had always bored me. Whether in people or in art it was the individual peculiarities that were interesting. One has sympathy with a hurt person, not because he is a generality, but precisely because he is not. Only the individual can imagine, invent, or create. The whole audience of

38

art is an audience of individuals. Each of them comes to the painting or sculpture because there he can be told that he, the individual, transcends all classes and flouts all predictions. In the work of art he finds his uniqueness affirmed.

Yes, one rankles at broad injustices, and one ardently hopes for and works toward mass improvements; but that is only because whatever mass there may be is made up of individuals, and each of them is able to feel and have hopes and dreams.

Nor would such a view invalidate a belief which I had held about the unifying power of art. I have always believed that the character of a society is largely shaped and unified by its great creative works, that a society is molded upon its epics, and that it imagines in terms of its created things—its cathedrals, its works of art, its musical treasures, its literary and philosophic works. One might say that a public may be so unified because the highly personal experience is held in common by the many individual members of the public. The great moment at which Oedipus in his remorse tears out his eyes is a private moment—one of deepest inward emotion. And yet that emotion, produced by art, and many other such private and profound emotions, experiences, and images bound together the Greek people into a great civilization, and bound others all over the earth to them for all time to come.

So I had crossed the terrain of the "social view," and I would not return. At the same time, I feel that all such artistic terrain which one has crossed must to some extent affect or modify his later work. Whatever one has rejected is in itself a tangible shaping force. That all such work improves the skill of the hand or the discernment of the eye is only a minor consideration. Even of one's thinking, however much his views may change, one retains a great deal, rejecting only that which seems foreign to him or irrelevant. Or, one may wholly reject the social view of man and at the same time cherish its underlying sympathies and its sense of altruism.

Such a process of acceptance and rejection—the artist plus the

inner critic—or you might just say, the informed creator—is present in the most fragmentary piece which an artist produces. A small sketch of Picasso's, a drawing by Rouault, or Manet or Modigliani, is not to be dismissed as negligible, for any such piece contains inevitably the long evolutionary process of taste, deftness, and personal view. It is, if brief, still dictated by the same broad experience and personal understanding which molds the larger work.

I was not the only artist who had been entranced by the social dream, and who could no longer reconcile that view with the private and inner objectives of art. As during the thirties art had been swept by mass ideas, so during the forties there took place a mass movement toward abstraction. Not only was the social dream rejected, but any dream at all. Many of those names that, during the thirties, had been affixed to paintings of hypothetical tyrannies and theoretical cures were now affixed to cubes and cones and threads and swirls of paint. Part of that work was—and is—beautiful and meaningful; part of it does indeed constitute private experience. A great part of it also represents only the rejection, only the absence of self-commitment.

The change in art, mine included, was accomplished during World War II. For me, it had begun during the late thirties when I worked in the Resettlement Administration. I had then crossed and recrossed many sections of the country, and had come to know well so many people of all kinds of belief and temperament, which they maintained with a transcendent indifference to their lot in life. Theories had melted before such experience. My own painting then had turned from what is called "social realism" into a sort of personal realism. I found the qualities of people a constant pleasure; there was the coal miner, a cellist, who organized a quartet for me —the quartet having three musicians. There was the muralist who painted the entire end of his barn with scenes of war and then of plenty, the whole painting entitled "Uncle Sam Did It All." There were the five Musgrove brothers who played five harmonicas—the

wonderful names of people, Plato Jordan and Jasper Lancaster, and of towns, Pity Me, and Tail Holt, and Bird-in Hand. There were the poor who were rich in spirit, and the rich who were also sometimes rich in spirit. There was the South and its story-telling art, stories of snakes and storms and haunted houses, enchanting; and yet such talent thriving in the same human shell with hopeless prejudices, bigotry, and ignorance.

Personal realism, personal observation of the way of people, the mood of life and places; all that is a great pleasure, but I felt some larger potentiality in art.

During the war I worked in the Office of War Information. We were supplied with a constant stream of material, photographic and other kinds of documentation of the decimation within enemy territory. There were the secret confidential horrible facts of the cartloads of dead; Greece, India, Poland. There were the blurred pictures of bombed-out places, so many of which I knew well and

cherished. There were the churches destroyed, the villages, the monasteries—Monte Cassino and Ravenna. At that time I painted only one theme, "Europa," you might call it. Particularly I painted Italy as I lamented it, or feared that it might have become.

It had been my principle in painting, during all the changes that I had undertaken, that outer objects or people must be observed with an acute eye for detail, but that all such observation must be molded from an inner view. I had felt consistently, also, that any such content must be painted in a way wholly subject to the kind of medium, whether oil, tempera, fresco, or whatever.

But now I saw art turning abstract, courting material alone. It seemed to me that such a direction promised only a cul-de-sac for the painter. I wanted to avoid that direction, and at the same time I wanted to find some deeper source of meaning in art, a constant spring that would not run dry with the next change in political weather.

Out of the battery of acceptances and rejections that mold the style of a painter, there rises as a force not only his own growing and changing work, but that of other work, both contemporary and past. He must observe all these directions and perhaps continue those which appear to be fruitful, while shunning those which appear to be limited and of short duration. Thus a degree of sophistication is essential to the painter.

While I felt a growing conviction as to the validity of the inner view, I wanted not to re-tread the ground which had been so admirably illuminated by Surrealism. Indeed the subconscious, the unconscious, the dream-world does offer a rich almost limitless panorama for the explorations of art; but in that approach, I think we may call it the psychological approach, one may discern beyond the rich imagery certain limits and inevitable pitfalls.

The limitation which circumscribed Surrealist art arose from its effort to reveal the subconscious. For in that effort control and intention were increasingly relinquished. Surrealism and the psychological approach led into that quagmire of the so-called automatic practices of art—the biomorphic, the fecal, the natal, and the other absurdities.

The subconscious may greatly shape one's art; undoubtedly it

does so. But the subconscious cannot create art. The very act of making a painting is an intending one; thus to intend and at the same time relinquish intention is a hopeless contradiction, albeit one that is exhibited on every hand.

But the great failure of all such art, at least in my own view, lies in the fact that man's most able self is his conscious self—his intending self. The psychological view can at best, even assuming that it were accurate, tell us what man is in spite of himself. It may perhaps discover those animal motives which are said to lurk beneath the human ones. It may unmask selfish purposes lying within altruism. It may even be able to reveal primitive psychological states underneath the claims and achievements of philosophy—the brute beneath the intellect. But the values of man, if he has any at all, reside in his intentions, in the degree to which he has moved away from the brute, in his intellect at its peak and in his humanity at its peak.

I do not conceive it to be the role of art to retrogress either into the pre-natal or into the pre-human state. So while I accept the vast inner landscape that extends off the boundaries of consciousness to be almost infinitely fruitful of images and symbols, I know that such images mean one thing to the psychologist and quite another to the artist.

One might return to Oedipus. For, to the psychologist, Oedipus is a symbol of aberration only—a medical symbol. But to the artist Oedipus is a symbol of moral anguish, and even more than that, of transcendent spiritual power.

Or, consider Van Gogh; to the psychologist it is the periodic insanity of Van Gogh that is pre-eminent, and the psychologist deduces much from that. But to the artist it is clear that it was the great love of things and of people and the incredible suffering of Van Gogh that made his art possible and his insanity inevitable.

I know that there must be an ingredient of complete belief in any work of art—belief in what one is doing. I do not doubt that

44

those artists who work only for pure form believe in form alone as the ultimate possible expression in art. Those who look upon their art as therapy probably believe with equal fervor in what they are doing. And I am sure that the artists who only manipulate materials believe firmly in that method. But here again one must be impelled by rejection. Such art can contain nothing of experience either inward or outward. It is only a painted curtain resting midway between the subjective and the objective, closing either off from the other.

To me both subjective and objective are of paramount importance, another aspect of the problem of image and idea. The challenge is not to abolish both from art, but rather to unite them into a single impression, an image of which meaning is an inalienable part.

I had once believed that the incidental, the individual, and the topical were enough; that in such instances of life all of life could be implied.

But then I came to feel that that was not enough. I wanted to reach farther, to tap some sort of universal experience, to create symbols that would have some such universal quality.

I made a series of paintings during the war which, in my own view—and what other view has an artist?—began to realize this more difficult objective. I shall discuss the pictures themselves, but again it is necessary to emphasize the conflict which arises in any such change of view, and the painful necessity to be aware of what one really thinks and wants in art.

I have already mentioned my personal dislike of generalities. Now, one must ask, is not the universal merely another term for the generality? How can one actually achieve a universality in painting without becoming merely more generalized and abstract? I feel that this question is one which greatly concerns artists. Its resolution will greatly affect the kind of an artist one is to be.

My own approach can only be to ask myself just why it is that

45

I so dislike all statistics and most generalities. The answer that I find is simply that I dislike such material because it is impersonal. In being average to all things, it is particular to none. If we were to attempt to construct an "average American" we would necessarily put together an effigy which would have the common qualities of all Americans, but would have the eccentricities, peculiarities, and

unique qualities of no American. It would, like the sociologist's statistical high-school student, approximate everyone and resemble no one.

But let us say that the universal is that unique thing which affirms the unique qualities of all things. The universal experience is that private experience which illuminates the private and personal world in which each of us lives the major part of his life. Thus, in art, the symbol which has vast universality may be some figure drawn from the most remote and inward recesses of consciousness; for it is here that we are unique and sovereign and most wholly aware. I think of Masaccio's "Expulsion from the Garden," so intensely personal that it leaves no person untouched. I think of a di Chirico figure, lonely in a lonely street haunted by shadows; its loneliness speaks to all human loneliness. As an experience, neither painting has anything of the average; both come from extreme limits of feeling and both paintings have a great universality.

The paintings which I made toward the close of the war—the "Liberation" picture, "The Red Staircase," "Pacific Landscape," "Cherubs and Children," "Italian Landscape," and quite a number of others did not perhaps depart sharply in style or appearance from my earlier work, but they had become more private and more inward-looking. A symbolism which I might once have considered cryptic now became the only means by which I could formulate the sense of emptiness and waste that the war gave me, and the sense of the littleness of people trying to live on through the enormity of war. I think that at that time I was very little concerned with communication as a conscious objective. Formulation itself was enough of a problem—to formulate into images, into painted surfaces, feelings, which, if obscure, were at least strongly felt.

But in my own view these paintings were successful. I found in them a way to go, actually a liberation of sorts for myself. I became most conscious then that the emotional image is not necessarily of that event in the outside world which prompts our feeling;

47

the emotional image is rather made up of the inner vestiges of many events. It is of that company of phantoms which we all own and which have no other sense than the fear sense, or that of the ludicrous, or of the terribly beautiful; images that have the nostalgia of childhood with possibly none of the facts of our childhood; images which may be drawn only from the recollection of paint upon a surface, and yet that have given one great exaltation—such are the images to be sensed and formulated.

I became increasingly preoccupied with the sense and the look, indeed, with the power of this newly emerging order of image. It was, as I have indicated, a product of active intentions plus the constant demands and rejections of the inward critic; even perhaps of a certain striving to measure my own work critically with some basic truth in art. At the same time I read and do read comments about my work by outer critics, some referring to the work as "Social Realism," some lamenting its degree of content, holding that to be irrelevant to any art, but most employing certain labels which, however friendly they may be in intention, have so little relation to the context of a painting. I believe that if it were left to artists to choose their own labels most would choose none. For most artists have expended a great deal of energy in scrambling out of classes and categories and pigeon-holes, aspiring toward some state of perfect freedom which unfortunately neither human limitations nor the law allows—not to mention the critics.

I don't just think, I know, that this long historical process which I have just described is present within the one painting of the fire animal which is called "Allegory." There is considerable content which extends through one's work, appearing, disappearing, changing, growing; there is the shaping power of rejection which I have discussed, and the constant activity of revising one's ideas—of thinking what one wants to think. All these elements are present to a greater or less degree in the work of any painter who is deeply occupied in trying to impress his personality upon inert matter.

48

But allowing all this procedure and material, I must now say that it is, in another sense, only background. It is formulative of taste; it is the stuff and make-up of the inner critic; it is the underground stream of ideas. But idea itself must always bow to the needs and demands of the material in which it is to be cast. The painter who stands before an empty canvas must think in terms of paint. If he is just beginning in the use of paint, the way may be extremely difficult for him because he may not yet have established a complete rapport with his medium. He does not yet know what it can do, and what it cannot do. He has not yet discovered that paint has a power by itself and in itself—or where that power lies, or how it relates to him. For with the practiced painter it is that relationship which counts; his inner images are paint images, as those of the poet are no doubt metrical word images and those of the musician tonal images.

From the moment at which a painter begins to strike figures of color upon a surface he must become acutely sensitive to the feel, the textures, the light, the relationships which arise before him. At one point he will mold the material according to an intention. At another he may yield intention—perhaps his whole concept—to emerging forms, to new implications within the painted surface. Idea itself—ideas, many ideas move back and forth across his mind as a constant traffic, dominated perhaps by larger currents and directions, by what he wants to think. Thus idea rises to the surface, grows, changes as a painting grows and develops. So one must say that painting is both creative and responsive. It is an intimately communicative affair between the painter and his painting, a conversation back and forth, the painting telling the painter even as it receives its shape and form.

Here too, the inward critic is ever at hand, perpetually advising and casting doubt. Here the work is overstated; there it is thin; in another place, muddiness is threatened; somewhere else it has lost connection with the whole; here it looks like an exercise in paint

49

alone; there, an area should be preserved; thus the critic, sometimes staying the hand of the painter, sometimes demanding a fresh approach, sometimes demanding that a whole work be abandoned—and sometimes not succeeding, for the will may be stubborn enough to override such good advice.

I have spoken of the tug of war between idea and image which at an earlier time in my painting had plagued me so greatly. I could not reconcile that conflict by simply abandoning idea, as so many artists had done. Such an approach may indeed simplify painting, but it also removes it from the arena of challenging, adult, fully intellectual and mature practice. For me, there would be little reason for painting if idea were not to emerge from the work. I cannot look upon myself or upon man generally as a merely behaving species. If there is value it rests upon the human ability to have idea, and indeed upon the stature of the idea itself.

The painting of the Red Beast, "Allegory," is an idea painting. It is also a highly emotional painting, and I hope that it is still primarily an image, a paint image. I began the painting, as I have said, with no established idea, only with the sense of a debt to be paid and with a clamoring of images, many of them. But as to the fire itself, and as to fires, I had many ideas, a whole sub-continent of ideas, none of which would be executed to measure, but any one of which might rise to become the dominating force in the painting. So it was with the series of paintings which I made during and after the time of the fire animal. There was the painting "Brothers." Paint, yes, but also reunion, reconciliation, end of war, pain of strong feeling, family, brothers. There was the painting called "City of Dreadful Night"—a forest of television aerials—lines in paint—splashes of light, or heads of ancient demons tangled in the antennae —a somber building with moldering Greek heads. All of these images arose out of paint, yes, but they also arose out of the somewhat ominous implications of television for the mind, for the culture. Out of a chain of connective ideas, responding to paint and color,

rises the image, the painted idea. Thus the work may turn in an amusing direction, in a satirical direction. Or sometimes images are found—image ideas which are capable of great amplification, which can be built up to a high point of expressive power, at least for my purposes.

I cannot question that such a two-way communication has always constituted the painting process, sometimes with greater insistence of idea, sometimes with less, or none. Personal style, be it that of Michelangelo, or that of Tintoretto, or of Titian or of Giotto, has always been that peculiar personal rapport which has developed between an artist and his medium.

So I feel that painting is by no means a limited medium, neither limited to idea alone, nor to paint alone. I feel that painting is able to contain whatever one thinks and all that he is. The images which may be drawn out of colored materials may have depth and luminosity measured by the artist's own power to recognize and respond to such qualities, and to develop them. Painting may reflect, even brilliantly, the very limitations of an artist, the innocence of eye of a Rousseau, of a Bombois, of a John Kane. Painting can, and it has at various times, contained the whole of scholarship. Painting can contain the politician in a Daumier, the insurgent in a Goya, the suppliant in a Masaccio. It is not a spoken idea alone, nor a legend, nor a simple use or intention that forms what I have called the biography of a painting. It is rather the wholeness of thinking and feeling within an individual; it is partly his time and place; it is partly his childhood or even his adult fears and pleasures, and it is very greatly his thinking what he wants to think.

For the sake of a few lines [wrote Rilke] *one must see many cities, men and things. One must know the animals, one must feel how the birds fly and know the gesture with which the small flowers open in the morning. One must be able to think back to roads in unknown regions, to unexpected meetings and to partings which*

*one had long seen coming; to days of childhood that are still unex-
plained, to parents that one had to hurt when they brought one
some joy and one did not grasp it (it was a joy for someone else);
to childhood illness that so strangely began with a number of pro-
found and grave transformations, to days in rooms withdrawn and
quiet and to mornings by the sea, to the sea itself, to seas, to nights
of travel that rushed along on high and flew with all the stars—and
it is not yet enough if one may think all of this. One must have
memories of many nights of love, none of which was like the others,
of the screams of women in labor, and of light, white, sleeping
women in childbed, closing again. But one must also have been be-
side the dying, one must have sat beside the dead in the room with
the open window and the fitful noises. And still it is not enough to
have memories. One must be able to forget them when they are
many, and one must have the great patience to wait until they come
again. For it is not yet the memories themselves. Not until they have
turned to blood within us, to glance, to gesture, nameless and no
longer to be distinguished from ourselves—not until then can it hap-
pen that in a most rare hour the first word of a verse arises in their
midst and goes forth from them.* [From *The Notebooks of Malte
Laurids Brigge*, New York, W. W. Norton and Co., Inc., 1949.]

The Shape
of Content

I would not ordinarily undertake a discussion of form in art, nor would I undertake a discussion of content. To me, they are inseparable. Form is formulation—the turning of content into a material entity, rendering a content accessible to others, giving it permanence, willing it to the race. Form is as varied as are the accidental meetings of nature. Form in art is as varied as idea itself.

It is the visible shape of all man's growth; it is the living picture of his tribe at its most primitive, and of his civilization at its most sophisticated state. Form is the many faces of the legend—bardic, epic, sculptural, musical, pictorial, architectural; it is the infinite images of religion; it is the expression and the remnant of self. Form is the very shape of content.

Think of numbers alone, and their expression in form, of three, for instance. Who knows how far back into time the idea of the triad extends? Forms in threes appeared everywhere in early art.

53

But then the Trinity arose in Christian theology—the Father, the Son, and the Holy Ghost, and was a new form-generating concept. It became desirable to turn the idea of Trinity into every possible medium, to turn it to every use. The challenge to formulate new expressions of three, to symbolize further the religious idea, actually became a sort of game. How vast is the iconography of three alone —the triptych, the trefoil window, the three-petaled fleur-de-lis, used everywhere; the triskelion in its hundreds of forms—three angels interwoven, three fish interwoven, three legs interwoven, three horses interwoven, and the famous trefoil knot with three loops; the divisions of churches into three, of hymns into three; the effort to compose pictures into threefold design. *Form—content.*

But the three, the Trinity, was only one small part of the stimulus to form which arose out of the vivid Christian legend: think of the immense and brilliant iconography which remains detailed for us and our delight—the Lion for Mark, the Ox for Luke, the Eagle for John, the Angel for Matthew; Lamb and Serpent and Phoenix and Peacock, each with its special meaning; symbols of keys and daggers and crosses, all challenging the artists and artisans and architects and sculptors to new kinds of invention. Sin and Temptation, Piety, and a thousand virtues and vices all transmuted into the materials of art, into form, remaining for us in mosaics, in frescoes, in carvings, forming capitols, cupolas, domes, inner walls and outer façades, tombs, and thrones. Wherever something was made, the legend turned it into form. *Wonderful form; wonderful content.*

Think also of the ancient epics of Greece, Persia, Egypt, and Rome, each with its profusion of image and incident, its *dramatis personae*, its hierarchy, its complicated rites, its fierce families— every such item a point of departure for the artist, a touchstone of form for the poet, a basis for elaboration, a vessel for personal content, a subject for craft, for excellence, for style, for idea. *Form— content.*

Form and content have been forcibly divided by a great deal of

present-day aesthetic opinion, and each, if one is to believe what he reads, goes its separate way. Content, in this sorry divorce, seems to be looked upon as the culprit. It is seldom mentioned in the consideration of a work of art; it is not in the well-informed vocabulary. Some critics consider any mention of content a display of bad taste. Some, more innocent and more modern, have been taught—schooled—to look at paintings in such a way as to make them wholly unaware of content.

Writing about art is more and more exclusively in terms of form. Characteristic comment from the magazines upon one artist's work will read as follows: "The scheme is of predominantly large areas of whites, ochres, umbers and blacks which break off abruptly into moments of rich blues with underlayers of purple." Of another artist, it is written: "White cuttings expand and contract, suspended in inky black scaffoldings which alternate as interstices and positive shapes." Of a third, we read, "There is, first, a preoccupation with space broken into color through prisms and planes. Then the movement alters slightly and shifts toward the large field of space lanced by rectilinear lines that ride off the edge of the canvas—" and so on.

From time to time the critic himself will *create* a content by describing the work in terms of some content-reference, as when one of the above uses the term "scaffolding"—seeming to hunger for some object that he may be able to hang onto. Or when another writer describes a nonobjective work as "an ascetic whirlpool of blacks and whites, a Spartan melodrama, alleviated only by piquant whispers of turquoise, yellow or olive . . ."

Such a nostalgia for content and meaning in art goes counter to the creed as it is set forth by the true spokesmen for the new doctrine. I have already mentioned the credo of that early modern who demanded that art display "nothing from life, no knowledge of its affairs, no familiarity with its emotions." A contemporary writer, Louis Danz, asks that the artist "deny the very existence of mind." Ezra Pound has called art "a fluid moving over and above the minds of men."

An eminent American critic speaking recently in London dwelt at length upon "horizontality" and "verticality" as finalities in art. Throwing upon a screen reproductions of one work by Jackson Pollock, and one page from the ancient Irish "Book of Kells," the critic found parallel after parallel between the two works—the two qualities named above, a certain nervousness of line common to the two, the intricately woven surface.

Coming at length to the differences between the two works, the critic pointed out that the "Book of Kells" was motivated by strong faith—by belief that lay outside the illuminated page. But Pollock had no such outside faith, only faith in the material paint. Again, the "Book of Kells" revealed craftsmanship, the craftsmanlike approach, but no such craftsmanship entered into the work of Pollock.

Necessarily the surface effects which can arise out of such art are limited. One writer divides such painting into categories according to the general surface shapes, his categories being (1) Pure Geometric, (2) Architectural and Mechanical Geometric, (3) Nat-

uralistic Geometric (I wonder what that means!), (4) Expressionist Geometric, (5) Expressionist Biomorphic, and so on.

Among all such trends, there are the differences. There is some factor that decides whether a work shall be rounded, geometrical, spiral, blurred, or whatever it is in shape.

Those differences are in point of view. Sometimes the point of view is stated by the artist himself; more often, certainly more prolixly, it is stated by the theorist, or aesthetician or critic. I wish to discuss certain of these points of view, and show—if I can—how a point of view conditions the paint surface which the artist creates.

Let us begin with the paint-alone point of view—the contention that material alone is sufficient in painting, the attitude that holds that any work of art should be devoid not only of subject, or of meaning, but even of intention itself.

I suppose that the most monumental work in this direction is the great canvas—occupying a whole wall—done by Clyfford Still and exhibited by the Museum of Modern Art a few years ago. The canvas is done in a dull all-over black, and has a single random drip of white coming down to (I would judge) about a foot from the top of the painting. There is nothing more. Then there are the paintings of Mark Rothko, sometimes much more colorful but also immense in size; there are the blurred squares of color done by Ad Reinhardt. And there are many painters who work in forms of paint almost entirely static in their effect. The work of these three painters is perhaps as content-less as anything to be seen currently, although there is always Malevitch's "White on White," which still holds first place in the competitive race against content.

Distinguished in appearance from such static work as I have just described is the painting of the late and very noted Jackson Pollock, whose pictures are, as everyone knows, tangled surfaces of threaded paint, sometimes splashed paint, sometimes dripped paint. There are the legion followers of Pollock among our young paint-

ers; there is the Frenchman Mathieu; there are several young artists whose paintings consist of one or two long agitated strokes.

These painters are of the paint-alone school too, but in their case it is the *act* of painting which is emphasized. The act is in some cases looked upon as therapeutic; in other cases it is looked upon as automatic. Then the artist becomes actor, sometimes in a drama of his own psyche, sometimes in a vast time-space drama, in which case he becomes only the medium (it is held) for great forces and movements of which he can have no knowledge, and over which he can have no control.

Thus Pollock spoke of "the paroxysm of creation." Mathieu, going further, dressed himself in the most eccentric of costumes in order to make his painting, "The Battle of the Bouvines." According to the critic, he was "dressed in black silk; he wore a white helmet and shoes and greaves and cross-bars. . . . It was our good fortune [he says] to witness the most unpredictable of ballets, a dance of dedicated ferocity, the grave elaboration of a magic rite . . ." And later, "Mathieu regards everything as totally absurd and shows this constantly in his behavior which is characterized by the most sovereign of dandyisms. He understands with complete lucidity all the dizzying propositions in the inexhaustible domain of the abstract, on which he has staked his whole life, every possible type of humanism having been rejected . . ."

The differences in such art surfaces are not differences of paint alone. They are differences of idea, differences of point of view, differences of objective. They are, even in this most extreme wing of non-content painting, simply differences of content.

I have said that form is the shape of content. We might now turn the statement around and say that form could not possibly exist without a content of some kind. It would be and apparently is impossible to conceive of form as apart from content. Even the ectoplasm of Sir Oliver Lodge and the homeliest household ghost have a content of some kind—the soul, the departed spirit. If the

content of a work of art is only the paint itself, so be it; it has that much content. We may now say, I believe, that the form of the most nonobjective painting consists of a given quantity of paint, shaped by content; its content consisting in a point of view, in a series of gestures, and in the accidental qualities of paint.

But there is a great deal of other content that enters into the turns and twists of abstract-to-nonobjective form. There is, for instance, mission, and even social milieu. Socially, we must note that there has been no other time in history when just this art could have taken place. It had to be preceded by Freud; it must necessarily be directed toward a public conversant with Freud, and in many cases the very suppositions upon which contemporary art is based are derived from Freud. Further, it had to be preceded by Picasso, by Kandinsky, by Klee, by Miró, by Mondrian, for its forms, whatever new departures they may have taken, are an inheritance from the earlier group of great imaginers.

All this is content within content-less art, but there is even more; there is a certain sort of proclamation involved, an imperative, a mission, to announce that *this is art;* that this is man even— at least the only kind of man that counts. The public itself is not worthy; it is only anonymous. Worth itself inheres only in the special few, the initiate.

Form is the visible shape of content. The forms of the most extreme varieties of the paint-alone aesthetic differ from those of other art because the content differs. And if content is the difference, we might wonder how the new content looks alongside the old.

A year or so ago I was one of the judges for the Pennsylvania Academy annual exhibition. When we, the judges, walked into the immense room where we were finally to decide on prizes, a curious sight met us. The new paintings stood around the wall on the floor before the places where they were to be hung. The old pictures, the Pennsylvania "Treasures," were still in place above them. I remem-

ber experiencing a certain thrill of pride as I noted the contrast. The new pictures constituted a very river of color around the floor; they glowed richly. And, in comparison, the older paintings, certainly constituting some of the very finest in pre-impressionist art, seemed almost a gray-to-tan monotone. I felt proud of my contemporaries, and of painting. The forms of the new work stood out bold and clear, and the colors were infinite. Invention and variety competed and seemed almost to obliterate the work hanging on the walls. I felt a little sad that the older artists were so limited in their use of color and that their work dimmed so alongside the new.

Later, as I sat at lunch, I kept remembering the Eakins—the Winslow Homer paintings, too, but mostly the Eakins—the "Cello Player." What was it about Eakins that was so compelling? There was no boldness of design there. Colors, elegant and muted, but not used for design—used actually quite descriptively. Perhaps it was partly realism, but then realism alone quite often leaves me cold. There was another kind of content in the Eakins painting; there was a certain intellectual attitude—a complete dedication to comprehending something, someone outside himself. There was an intensity of honesty, a personal simplicity present in the work itself. Odd, that by departing utterly from himself, an artist could so reveal himself.

What a departure, what a contradiction to the canons of art which we hold so inviolate today! Eakins, full of content, full of story, of perfection of likeness, of naturalness, of observation of small things—the look of wood and cloth and a face—seeking to reveal character in his painting, loving the incidental beauty of things, but loving even more the actual way of things—sympathy, honesty, dedication, visible apprehensible shape. *Form—content.*

Almost anyone will tell you that, in terms of form, Eakins simply does not exist. But again, we must look upon form as the shape of content: with Eakins, no less than with de Kooning, or Stamos or Baziotes, form is the right and only possible shape of a certain

content. Some other kind of form would have conveyed a different meaning and a different attitude. So when we sit in judgment upon a certain kind of form—and it is usually called lack of form—what we do actually is to sit in judgment upon a certain kind of content.

I have mentioned some of the surface shapes which are characteristic of contemporary painting, and some of the classifications into which painting is put, depending upon whether it displays a rounded shape, squarish, angular, or some other sort of shape. I have pointed out that even with the renouncement of content, some content does remain, if only of verticality and horizontality.

There is little art being produced today that does not bear some imprint of the great period of the "Isms" when painting was freed from that academic dictatorship which had laid down so many rules about both form and content. Every branch of the rebellion of the Isms had, as we know, a content of ideas, and that content charted the course which it would pursue, as Cubism, for instance, pursued the cube, the cone, and the sphere, as Surrealism pursued the subconscious, and Dadaism, perversity.

Out of those ideas there emerged a new universe of forms, an aesthetic rebirth. Both the forms and the ideas are necessarily present to some degree in the work of us who have come later, and who are familiar with the ideas and images thus generated. Content, purpose, idea all provide new direction and new shape, but all are united in a certain modernity, in the sharing of a common art inheritance.

Abstraction is perhaps the most classic of the contemporary points of view. It sometimes seems to have much in common with that art which has sought to reject content, but actually it has not, for in the case of abstraction content is its point of departure, its cue, and its theme. To abstract is to draw out the essence of a matter. To abstract in art is to separate certain fundamentals from the irrelevant material which surrounds them. An artist may abstract the

63

essential form of an object by freeing it from perspective, or by freeing it from details. He may, for instance, interpret Jazz—an idea, a content—by abstracting out of a confusion of figures and instruments just the staccato rhythms and the blare. In Stuart Davis' paintings of jazz, for example, or in Matisse's, blaring sound becomes blaring color; rhythm of timing becomes rhythm of forms. Content, particularly with Davis, is not just jazz; it is the interpreta-

64

tion of an age with its shocks, its neon-lighted glare, its impacts on all the senses, its violent movements in which the eye glimpses everything and grasps nothing—a highly intellectual content formulated into a single immediate impression.

If Abstraction itself is the most classic of the modern modes, Abstract Expressionism, so-called, is the most prevalent. One might be entitled to expect of this view—judging from its name—that it would take almost as many outward forms as there are inward, or expressive, differences between artists.

Actually, I think that the varieties of form in Abstract Expressionist art are fewer than we might expect. Although the title is a loose one, and can be expanded to include almost anything, it seems usually to be applied to about three or four directions in form. It may indicate that painting which takes the form of whirls and swirls upon a surface, or it may be applied to painting in squares, or geometric patterns. Sometimes its shapes are rounded, having, I believe it is said, a biologic connection. Sometimes the forms may have an angular or spiked look. The theory underlying Abstract Expressionism has points in common with completely nonobjective views. Performance is likely to be held an essential part of the art process —the act, as against a controlled objective. But, as to the result, I think that this view admits of content—that content being the true impulsive compulsive self, revealed in paint.

If art seeks to divorce itself from meaningful and associative images, if it holds material alone as its objective, then I think that the material itself ought to have the greatest possible plasticity, the greatest potentialities for the development of shapes and the creating of relationships. For that reason I think that the sculpture which has been created with a view to being form alone has been a great deal more successful and interesting than has been the painting in that vein. The sculptor sets out with two pre-existing advantages: one, that he must have craftsmanship, and the other, that he works in the round. He does not have to simulate depth nor create illu-

sions of depth because he works in volume—in three-dimensional form.

Thus Noguchi, working in marble, is able to develop relationships in three dimensions rather than two and yet retain both simplicity and unity. He has at his disposal the advantages of light and space, and the natural translucence and glow of marble, all of which he exploits and reveals with great elegance.

Henry Moore is one of the great contemporary imaginers who has brought new materials and new concepts into sculptural form. He discovers the naturally heroic character of bronze and exploits feelingly the graining and fine surfaces of wood. Undoubtedly his most remarkable feat has been the surrounding of open space and his use of such space as a sculptural material. But beauty and craft and idea are still paramount with Moore, and he never obliterates these qualities in the shock of the new.

Unique in any age is Calder, who is, I think, the only one of the modern people who has actually and physically introduced a time dimension into his work. (It is sometimes held that the work of certain of the "paroxysmic" kind of painters represents a sort of time-space extension, that it expresses the action of immense physical forces; but I cannot escape the conviction that such an identification is more romantic than real; that it expresses only a wish to be identified with the new, to participate in the vitality and centralness of a science—of physics—which has so greatly shaped the mood and sense of our time.) Calder's work requires no terminology to identify it with that which is modern. It reads at once, and for anyone, and for a long time. While its shapes and forms are of an abstract genre, its meanings involve that return to nature, to first principles, which seems to be an indispensable condition of any great work of art or movement in art. Calder, once an engineer himself, but also son and grandson of sculptors, undoubtedly brought to engineering an eye for beauty, a sensitivity to aesthetic meanings which would wholly escape the usual engineer. Thus, in stress and balance, in

66

sequences of motion, in other basic and natural and probably common principles, he saw tremendous aesthetic potentialities, and put them to work.

The result for us who watch the continuously interdependent movements, the varieties of form balanced daringly and with delicate precision, is to experience the perfect union of nature and art. Here is sculpture that creates endless patterns in space—time-rhythms. Of course Calder's own great sense of play enters into all this, adding its own peculiar gaiety to the forms.

And then there are other interesting and diverse kinds of content that find expression in contemporary sculpture. I remember listening to a remarkable speech on the qualities of black alone which David Smith delivered spontaneously before an aesthetics conference a few years ago. It would be hard to believe that so much could be said of black—of its qualities, of its personal meanings, of its variety—unless we look at David Smith's sculpture where it is all so feelingly expressed.

In painting, there are additional kinds of content which help to set the look and the shape and the colors of the work that we see today. There is a certain moody poetic content, sometimes an emotional attitude toward nature—toward the sea, strange places, aspects of the city, even objects which have some odd emotional connection. Such content is sometimes expressed formally in abstract paintings which have only a vague reminiscence of actual things. Again, it may be present in actual scenes or objects strongly overbalanced by some one quality, so that only the feeling is present, as in Loren MacIver's painting of Venice—the Venice of lights only. Or there are Reuben Tam's seascapes, the moon or the sun in black, or swallowed by the sea. There are many extremely fine painters who work in this vein, and it constitutes to my mind one of the highest and most worthy expressions in the modern idiom.

Then there are the avowedly figurative painters whose point of departure is idea, attitude toward things and people, content of

all kinds, not excluding story content. Even among such painters, and I include myself among them, the impress of abstraction and expressionism is strong. The variations in form, in the look of painting, may be greater among the artists of this vaguely defined and scattered group than among artists of some of the other groups, simply because they have little in common aside from the fact that most of them work in objective images—things, places, and people. Not in any other age but ours would such a painter as Jack Levine —satirist of manners, observer, commentator, craftsman, and, in a sense, traditionalist—be aligned with such a painter as Tamayo—the designer, the imaginer, originator of strange beasts and men in all the possible mutations of red. What have they in common? That they paint content, figures! Nor would Philip Evergood be placed alongside Kuniyoshi, or Jacob Lawrence or Hyman Bloom, except that all are "content" painters.

Content, in the view of Panofsky, is "that which a work betrays but does not parade." In his book, *Meaning in the Visual Arts*, he calls it "the basic attitude of a nation, a period, a class, a religious persuasion—all this qualified by one personality, and condensed into one work. It is obvious," says Mr. Panofsky, "that such an involuntary relationship will be obscured in proportion as one of the two elements, idea or form, is voluntarily emphasized or suppressed. A spinning machine," he says, "is perhaps the most impressive manifestation of a functional idea, and an abstract painting is probably the most expressive manifestation of pure form. But both have a minimum of content."

Form arises in many ways. Form in nature emerges from the impact of order upon order, of element upon element, as of the forms of lightning or of ocean waves. Or form may emerge from the impact of elements upon materials, as of wind-carved rocks, and dunes. Form in living things too is the impinging of order upon order—the slow evolving of shapes according to function, and drift, and need. And other shapes—the ear, the hand—what mind could devise such

68

shapes! The veining of leaves, of nerves, of roots; the unimaginable varieties of shape of aquatic things.

Forms of artifacts grow out of use, too, and out of the accidental meetings of materials. Who again could dream of or devise a form so elegant as that of the chemical retort, except that need and use, and glass and glass-blowing all met to create form? Or the forms of houses, the Greek, the Roman, the extremely modern, or the

gingerbread house; these the creations out of different materials, and tools, and crafts, and needs—the needs of living and of imagining.

Forms in art arise from the impact of idea upon material, or the impinging of mind upon material. They stem out of the human wish to formulate ideas, to recreate them into entities, so that meanings will not depart fitfully as they do from the mind, so that thinking and belief and attitudes may endure as actual things.

I do not at all hold that the mere presence of content, of subject matter, the *intention* to say something, will magically guarantee the emergence of such content into successful form. Not at all! How often indeed does the intended bellow of industrial power turn to a falsetto on the savings bank walls! How often does the intended lofty angels choir for the downtown church come off resembling somehow a sorority pillow fight!

For form is not just the intention of content; it is the embodiment of content. Form is based, first, upon a supposition, a theme. Form is, second, a marshaling of materials, the inert matter in which the theme is to be cast. Form is, third, a setting of boundaries, of limits, the whole extent of idea, *but no more*, an outer shape of idea. Form is, next, the relating of inner shapes to the outer limits, the initial establishing of harmonies. Form is, further, the abolishing of excessive content, of content that falls outside the true limits of the theme. It is the abolishing of excessive materials, whatever material is extraneous to inner harmony, to the order of shapes now established. Form is thus a discipline, an ordering, according to the needs of content.

In its initial premises, content itself may be anything. It may be humble or intimate, perhaps only the contemplation of a pine bough. Or it may strive toward the most exalted in idea or emotion. In such an initial theme lies the cue, the point of departure, the touchstone of shape. But from that point, from the setting of theme, the development of form must be a penetration of inner relation-

ships, a constant elimination of nonpertinent matter both of content and of shape. Sometimes, if extreme simplicity is an objective, an artist's whole effort must be bent toward the casting aside of extra matter. Sometimes, if the theme is exalted, tremendous energy must be poured into the very act of reaching toward, of seeking to fulfill the boundaries of that theme which has been set. Perhaps the most heroic performance in this direction that the world has even known—at least on the part of one man—was the creation of the Sistine ceiling by Michelangelo. Here was the setting of a formal plan so vast that its enactment alone became an almost superhuman task; moreover, there was the establishment of a pitch of

feeling which could not be let down or diminished in any place—and which was not diminished!

Content, I have said, may be anything. Whatever crosses the human mind may be fit content for art—in the right hands. It is out of the variety of experience that we have derived varieties of form; and it is out of the challenge of great idea that we have gained the great in form—the immense harmonies in music, the meaningful related actions of the drama, a wealth of form and style and shape in painting and poetry.

Content may be and often is trivial. But I do not think that any person may pronounce either upon the weight or upon the triviality of an idea before its execution into a work of art. It is only after its execution that we may note that it was fruitful of greatness or variety or interest.

We have seen so often in past instances how content that was thought unworthy for art has risen to the very heights. Almost every great artist from Cimabue to Picasso has broken down some pre-existing canon of what was proper material for painting. Perhaps it is the fullness of feeling with which the artist addresses himself to his theme that will determine, finally, its stature or its seriousness. But I think that it can be said with certainty that the form which does emerge cannot be greater than the content which went into it. For form is only the manifestation, the shape of content.

On Nonconformity

The artist is likely to be looked upon with some uneasiness by the more conservative members of society. He seems a little unpredictable. Who knows but that he may arrive for dinner in a red shirt . . . appear unexpectedly bearded . . . offer, freely, unsolicited advice . . . or even ship off one of his ears to some unwilling recipient? However glorious the history of art, the history of artists is quite another matter. And in any well-ordered household the very thought that one of the young may turn out to be an artist can be a cause for general alarm. It may be a point of great pride to have a Van Gogh on the living room wall, but the prospect of having Van Gogh himself in the living room would put a good many devoted art lovers to rout.

A great deal of the uneasiness about artists is based upon fiction; a great deal of it also is founded upon a real nonconformity which artists do follow, and which they sometimes deliberately exaggerate, but which seems nevertheless to be innate in art. I do not mean to imply at all that every artist is a nonconformist or even that most artists are nonconformists. I daresay that if we could somehow se-

73

cure the total record it would show that an enormous majority of painters, sculptors, and even etchers have been impeccably correct in every detail of their behavior. Unfortunately, however, most of these artists have been forgotten. There seems to have been nothing about them, or even about their work actually, that was able to capture the world's attention or affection. Who knows? Perhaps they were too right, or too correct, but in any case we hardly remember them or know who they were.

There was a great commotion aroused in Paris around 1925 when it was proposed by officials that one of the pavilions of the coming Exposition des Arts Décoratifs be housed in that space traditionally reserved for the Salon of the Independents. It was suggested that, in view of the new enlightenment, there was actually no further need of an Independents' show in Paris. An indignant critic promptly offered to give twenty-five reasons why the Independents' show ought to be continued.

The twenty-five reasons proved to be twenty-five names—those of the winners of the Prix de Rome over as many years, the Prix de Rome being the most exalted award that can be extended to talented artists by the French Government. But all these names, excepting that of Rouault, were totally unknown to art. The critic then called off twenty-five other names, those of artists who had first exhibited with the Independents, who had not won a Prix de Rome, and who could not by any stretch of the imagination have won such an award. They were Cézanne, Monet, Manet, Degas, Derain, Daumier, Matisse, Utrillo, Picasso, Van Gogh, Toulouse-Lautrec, Braque, Gauguin, Léger, and so on and on.

This incident has great bearing upon the matter of conformity. For it was through the questionable virtue of conformity that the Prix de Rome winners had prevailed. That is to say, they had no quarrel with art as it stood. The accepted concepts of beauty, of appropriate subject matter, of design, the small conceits of style, and the whole conventional system of art and art teaching were

74

perfectly agreeable to them. By fulfilling current standards drawn out of past art, the applicants had won the approval of officials whose standards also were based upon past art, and who could hardly be expected to have visions of the future. But it is always in

the future that the course of art lies, and so all the guesses of the officials were wrong guesses.

What is it about us, the public, and what is it about conformity itself that causes us all to require it of our neighbors and of our artists and then, with consummate fickleness, to forget those who fall into line and eternally celebrate those who do not?

Might not one surmise that there is some degree of nonconformity in us all, perhaps conquered or suppressed in the interest of our general well-being, but able to be touched or rekindled or inspired by just the quality of unorthodoxy which is so deeply embedded in art?

I doubt that good psychological or sociological opinion would allow such a view. On the contrary, I think that the most advanced opinion in these fields holds that we are by our natures doomed to conformity. We seem to be hemmed in by peer groups, hedged by tradition, struck dumb by archetypes; to be other-directed, inner-directed, outer-directed, over directed. We are the organization man. It is not allowed that we may think for ourselves or be different or create something better than that which was before.

Since I do not myself aspire to being a sociologist, I do not feel particularly committed to correct sociological behavior. I don't care a rap about my peer group. And as for my tradition, brave though it may be and nostalgic, still I feel that I am on the whole well out of it. I cannot believe in Statistical Man or Reisman Man (Reis-Man?) and I can even dream of a day when perhaps both shall be ranged alongside Piltdown Man in some wonderful museum of scientific follies.

Nonconformity is not only a desirable thing, it is a factual thing. One need only remark that all art is based upon nonconformity—a point that I shall undertake to establish—and that every great historical change has been based upon nonconformity, has been bought either with the blood or with the reputation of nonconformists. Without nonconformity we would have had no Bill of Rights or Magna Charta, no public education system, no nation upon this continent, no continent, no science at all, no philosophy, and considerably fewer religions. All that is pretty obvious.

But it seems to be less obvious somehow that to create anything at all in any field, and especially anything of outstanding worth, requires nonconformity, or a want of satisfaction with things as

76

they are. The creative person—the nonconformist—may be in profound disagreement with the present way of things, or he may simply wish to add his views, to render a personal account of matters.

Let me indicate the mildest kind of nonconformity that I can think of. A painter, let us say, may be perfectly pleased and satisfied with art just as it stands. He may like the modern and lean toward the abstract. Within the abstract mode, however, he may envision possibilities and powers not yet exploited. Perhaps he is interested in light. He may feel confident that with the enormous freedom of manipulation afforded by abstract techniques he himself can produce something new. He may believe that by relating colors and forms in a certain way—by forcing them perhaps—he can produce unheard-of luminosities. Even though many of his friends may feel that he is engaged upon a ridiculous project, he will pursue his vision, and he will probably ultimately realize it. Such a man may be perfectly circumspect in his behavior, and may have no quarrel even with art. The point of his nonconformity will be just at the point of his new vision, of his confidence that it can be realized. There he takes lessons from no one, and is his own authority.

If there is nothing in the code, if there is no doctrine which holds that light is a wrong and undesirable thing, then the artist's nonconformity is taken for granted as part of the art process. But if there happens to exist some such stricture, some rule or academic principle, or some official body or tribunal to obstruct his work or take issue with his purpose, then nonconformity becomes rebellion, intransigence.

One thinks of Turner, for this great innovator did manipulate colors and suppress forms to create light. He anticipated Impressionism by so many years, and he violated every accepted canon of academic art. Radical though he was, Turner created no outright explosion, simply because his work encountered little opposition beyond being called "tinted steam" by Constable and "soapsuds and whitewash" by someone else.

77

How different was the case with the Impressionists who, with objectives almost the same as those of Turner, were made the outlaws and the outcasts of art, their paintings ostracized by academic edict. The French Academy, which held official status and some material power, had been able to set up a certain absolutism of standards. It had pronounced upon the proper aims and objectives of painting, and the creation of pure and unalloyed light was not among them—particularly light gained at the expense of the entrenched method of underpainting in black, a heritage from the now-sacred Renaissance. The Academy did seek to obstruct and curtail Impressionist nonconformity, and thus produced the greatest art upheaval in history.

Nonconformity, even on a vast scale, does not necessarily imply any sort of violent or total overthrow. The transition from Medieval art into that of the Renaissance was accomplished by the modest personal ventures of such gentle painters as Giotto, Cimabue, Duccio, and Ambrogio Lorenzetti, each of whom created his humane and freshly observed images within the framework of the Medieval manner.

The Renaissance was of course a time of extraordinary artistic latitude, a time tolerant of nonconformity, able to expand to accommodate all sorts of styles and viewpoints, to endure the mediocre as well as to applaud the great, to be at once religious and pagan and classic. The world has enjoyed few such respites from rigidity of mind—perhaps a space of a few hundred years in Greece, a period in France from the Enlightenment almost to the present, Victorian England—but whenever they have occurred a flowering has taken place—in the arts, in science, in literature, and most significantly, in life.

Every successive change in the look of art, that is, every great movement, has been at issue with whatever mode was the then prevailing one. Protestantism in art seems almost to have preceded Protestantism in religion. The high style of the Italians, even though

it constituted the very model and ideal of Dutch and Flemish and German painters, still appears somehow too florid for the lean and frugal Northern temperament. Holbein, Dürer, Grünewald, and Bosch were earth-oriented and did not or could not aspire to such sky-ey matters as the wonderful cloud-surrounded Transfigurations and Apotheoses at which the Italians excelled.

Protestant art itself was conscientiously, defiantly, earth-oriented, and in opposition to it there was created the art of the Catholic Counter-Reformation with the almost studied return to splendor. To Rubens, its greatest artistic spokesman, no excess of elaboration, ornamentation, or glorification of Church and nobility seemed unacceptable. As such lavishness descended to Rococo, there arose almost as if in revulsion the severe Neo-Classicism of David and Ingres, a fast after too-prolonged feasting. The Romanticism of Gericault and Delacroix may well have been a recoil from just that neo-classic sterility. The Realism of Courbet took issue with romantic effulgence; Impressionism and all the Isms that followed it were a fragmentation of Realism, and then a denial and then an outright opposition to Realism. All of which is not to elaborate upon the history of art movements, but only to point out the essential fact of nonconformity.

The artist occupies a unique position vis-à-vis the society in which he lives. However dependent upon it he may be for his livelihood, he is still somewhat removed from its immediate struggles for social status or for economic supremacy. He has no really vested interest in the status quo.

The only vested interest—or one might say, professional concern—which he does have in the present way of things rests in his ability to observe them, to assimilate the multifarious details of reality, to form some intelligent opinion about the society or at least an opinion consistent with his temperament.

That being the case, he must maintain an attitude at once detached and deeply involved. Detached, in that he must view all

79

things with an outer and abstracting eye. Shapes rest against shapes; colors augment colors, and modify and relate and mingle mutually. Contrasts in life move constantly across the field of vision—tensions between the grotesque and the sad, between the contemptible and the much-loved; tensions of such special character as to be almost imperceptible; dramatic, emotional situations within the most banal settings. Only the detached eye is able to perceive these properties and qualities of things.

Within such contrasts and juxtapositions lies the very essence of what life is today, or any day. Whoever would know his day or would capture its essential character must maintain such a degree of detachment.

But besides perceiving these things, the artist must also feel them. Therein he differs from the scientist, who may observe dis-

passionately, collate, draw conclusions, and still remain uninvolved. The artist may not use lines or colors or forms unless he is able to feel their rightness. If a face or a figure or a stretch of grass or a formal passage fails in that sense, then there is no further authority for it and no other standard of measurement. So, he must never fail to be involved in the pleasures and the desperations of mankind, for in them lies the very source of feeling upon which the work of art is registered. Feeling, being always specific and never generalized, must have its own vocabulary of things experienced and felt.

It is because of these parallel habits of detachment and of emotional involvement that artists so often become critics of society, and so often become partisans in its burning causes. And also it is why they are so likely to be nonconformists in their personal lives. Michelangelo, Leonardo, and Rembrandt were all noted noncon-

formists, each one of them expanding freely the set limits of mind and art and behavior. Dürer was a passionate admirer of the heretical Martin Luther, David a prime figure in the French Revolution; Courbet helped push over the Vendôme Column during the period of the Paris Commune, calling it a symbol of war and imperialism. Even the American Revolution had an artist participant in Charles Willson Peale (not to mention Paul Revere). The instances are numerous: I remember the Paris of the twenties when the cafés teemed with talk of the still-to-be-created New World, and when every smallest aesthetic deviation had its own political manifesto; then the thirties in New York and the depression, when almost no artist was without some sort of identification with political or social theory, a solution for his time.

But considerably more revealing than active engagement or the personal behavior of artists has been the passionate testament of their sympathies as it is written across the canvases and walls of the world and carved into its buildings and filed away within its archives in engravings, woodcuts, lithographs, and drawings. Here the intransigent sentiments are stamped indelibly and are inseparable from the art itself.

One of the earliest of such testaments was painted by Ambrogio Lorenzetti in the early 1300's and spreads over three vast walls of the Council Chamber in the Palazzo Púbblico in Siena. A dissertation upon the sins of bad government and the virtues of good, it remains a monument to the medieval *Free City,* a beautiful and majestic dream of justice. One of the latest of such testaments is Picasso's "Guernica."

Compassion with human woes threads through all art from Masaccio's anguished "Adam and Eve" to the bitter sufferers of Käthe Kollwitz' "Weavers' Strike" and on down to the present, although for the moment it may have thinned. Partisanship on the side of the humble has been an ever recurring passion in art—Brueghel, Rembrandt, Daumier. And with these three and so many

others, there is always the other side of the coin, the thrusts and satires upon social and political malpractice. *Nonconformity.*

While artists try to make their nonconformity as clear and unmistakable as possible, one of the challenging tasks of criticism seems to be to smooth over such nonconformity, and to make it appear that this or that artist was a very model of propriety. We read this sort of thing, "The coarseness of Goya is hardly noticeable unless we set out to look for it." Or again, "There is no evidence to prove that Goya actively assisted in any scheme of protest against the established order of society." But of course Goya did actively assist; indeed he protested with the most crying, the most effective, the most unforgettable indictment of the horrors of religious and patriotic fanaticism that has ever been created in any medium at all. Beauty? Yes it is beautiful, but its beauty is inseparable from its power and its content. Who is to say when a weeping face becomes a trenchant line? And who may presume to know that the line might have been trenchant apart from the face? Who can say that this passage of color, that formal arrangement, this kind of brush-stroking could have come into being were it not for the intensity of belief which demanded it?

And so one reads of the color, the form, the shape, the structure —all of this apart from the meaning which they hold, and apart from the context of life in which they took place. The fierce and dreadful fantasies of Brueghel become "cryptic iconography" with little reference to the reality of tortures, violence, and burnings at the stake, those common practices of the Spanish occupation and its own peculiar tribunal—the Blood Council.

Of course these artists were nonconformists. Indeed each of them stands out as an island of civilized feeling in an ocean of corruption. Civilization has freely vindicated them in everything but their nonconformity.

It is an amusing contradiction of our time that we do applaud a sort of copy-book nonconformity. Everyone laments the increase

83

in conformity; everyone knows that too much conformity is bad for art and literature and politics, and that it may deal the death-blow to National Greatness. The deadening effects of over-conformity are well understood. Yet, when it comes to the matter of just what kind of nonconformity shall be encouraged, liberality of view recedes. There seems to be no exact place where nonconformity can be fitted in. It must not be admitted into the university curriculum—that would produce chaos. In politics it is certainly inadvisable—at least for the time being. It cannot be practiced in journalism—witness the recent stoppage of Eric Severeid's broadcast upon a free press. In science—least of all, alas! As to nonconformity on the part of people in public office, the trials of Mr. Secretary Wilson ought to be enough to warn anyone against excessive outspokenness.

Without the person of outspoken opinion, however, without the critic, without the visionary, without the nonconformist, any society of whatever degree of perfection must fall into decay. Its habits (let us say its virtues) will inevitably become entrenched and tyrannical; its controls will become inaccessible to the ordinary citizen.

But I do not wish to underrate the importance of the conformist himself—or perhaps an apter term would be the conservative. In art, the conservative is the vigorous custodian of the artistic treasures of a civilization, of its established values and its tastes—those of the past and even those present ones which have become accepted. Without the conservative we would know little of the circumstances of past art; we would have lost much of its meaning; in fact, we would probably have lost most of the art itself. However greatly the creative artist may chafe at entrenched conservatism, it is still quite true that his own work is both sustained and enriched by it.

It is natural and desirable that there should occur some conflict between these two kinds of people so necessary to each other and

84

yet so opposite in their perspectives. I have always held a notion of a healthy society as one in which the two opposing elements, the conservative and the creative (or radical, or visionary, or whatever term is best applied to the dissident), exist in a mutual balance. The conservative, with its vested interest in things as they are, holds onto the present, gives stability, and preserves established values (and keeps the banks open). The visionary, always able to see the configuration of the future in present things, presses for change, experiment, the venture into new ways. A truly creative artist is inevitably of this part of the society.

There takes place from time to time an imbalance between the stabilizing and the visionary elements in society. Conformity is then pressed upon everyone, and growth and change and art come to a standstill.

In the year 1573, the painter Veronese was summoned before the Inquisition to answer a charge of blasphemy. In a painting of the Last Supper he had created an outer scene of worldliness in contrast to the inner scene of solemnity. Among the figures of the outer scene was a dog, and it was the dog that constituted the blasphemy. Ten years earlier the Council of Trent had decided upon the proper iconography for this and other religious scenes; their decision was held to be final, and a dog was not among the items listed.

The painter sought to explain the formal considerations which had led to his arrangement. His explanation was disregarded and he was ordered to substitute a Magdalene for the dog or be subject to whatever penalty the Holy Tribunal should decide to impose. Veronese did not yield; he retained the dog and changed the title of the painting. But let us note that art itself did yield to the increased pressure for conformity. It was in an atmosphere of enforced acts of faith, of fear of heresy, of trial and ordeal, and of the increasing harshness of the Inquisition that three hundred years of Renaissance greatness came to a close in Italy.

In our own generation, there is a record of a Russian trial not dissimilar to that of Veronese. A Soviet painter named Nikritin was accused of decadent Western formalism in a painting which he had made of a sports event, the specific complaint being that he had employed symbolic devices at the expense of Soviet Realism. Defending himself before a tribunal made up of fellow-artists and a member of a cultural bureau, Nikritin explained the artistic reasons which had prompted his choice and arrangement of figures. His defense was unsuccessful. It was decided that such symbolic treatment as that which he had employed was not understandable to workers and was indeed an affront to them. One of his fellow-artists described him as "one of those fellows who want to talk at all cost about themselves . . . an undesirable type of artist." The

verdict: "What we see here is calumny; it is a class attack inimical to Soviet power. The picture must be removed and the appropriate steps taken."

Perhaps equally significant is a story related by my brother after he had returned from a trip to the Soviet Union. He was curious about the status of art there and arranged to meet a number of artists. After he had visited several studios he was struck by the fact that all the artists seemed to be working in groups rather than singly and to be producing more or less the same subject-matter. After a great deal of inquiring he learned of one man who painted alone, and he made his way to this man's studio. There he found the solitary painter, the individualist, who in spite of hardships was carrying on. When my brother looked at his work he was astonished to find that this man was painting exactly the same subject matter—the idealized workers, anti-capitalist themes, and portraits of heroes which the collective artists were doing. Conformity is a mood and an atmosphere, a failure of hope or belief or rebellion.

I do not know of any trials which actually took place during the Hitler regime in Germany. But it is well known that the function of art was determined by edict during that time, that art was charged with carrying out the policies of the State. It was to be Nordic; it was to reject the so-called degenerate forms current in the Democracies; it was to be purged of Semitic influences. German Expressionism, one of the most brilliant art movements of modern times came to an abrupt end. Its artists scattered across Europe and America—those that were fortunate enough to escape in time. And there arose in its place a cloying art of *kirche*, *küche*, and *kinder*, stillborn and unremembered.

Nonconformity is the basic pre-condition of art, as it is the precondition of good thinking and therefore of growth and greatness in a people. The degree of nonconformity present—and tolerated—in a society might be looked upon as a symptom of its state of health.

The greater number of artists at any time whatever are no doubt complete conformists—not the outstanding ones, but the numerical majority. That is simply because mediocrity is commoner than that accumulation of talents which is called genius. There is always an impressive number of artists who are overwhelmed by the nearest outstanding figure. They adopt his point of view and mannerisms and become a school; that is one kind of art conformity.

Another kind of conformity is derived from the wholly venal business of catering to a popular market. Still another results from trends and the yearning of artists—an almost irresistible yearning—to be in the forefront of things. I am sure that every professional writer on art feels the need to produce at least one wave of the future per season, and once he has hit upon it, there is a considerable rush among artists to be seen at the crest. I will have a little more to say about this sort of conformity at a later time.

All these kinds of conformity are inevitable and to be expected. But there has grown around us a vastly increased conformity. One could say "conformism" here; for this is conformity by doctrine and by tribunal.

We are all prone to attribute the new conformity to television and mass communications, and indeed they do play their part. But television is not so much guilty as it is itself the victim of conformism. For it has been tried on the basis of possible disloyalty; it has been purged, but not exonerated. It remains in a state of suspended verdict, liable to re-examination at any time.

So with radio; so with films; so with the press; so with education; so with all those professions which involve the exercise of judgment, intellect, and creativity.

Art has not yet come in for its official purgation although it is understood to be on the docket. Nevertheless it has had its own ordeal of conformity. And it has its own Congressional scourge in the person of a Midwestern Congressman who provides the *Congressional Record* with periodic messages under the heading: "Exten-

sion of Remarks by Congressman Dondero." In the shelter of his privilege he has recorded a list of artists whom he has designated as "international art thugs," "art vermin," "subversives of art," and so on. To museums and museum directors, that is, those interested in contemporary art, he has attributed reprehensible motives and practices. He regards modern art forms as a disguised plot to undermine our morals and our "glorious American art." Such are the bludgeons of conformity.

So alerted, some sections of the public have felt that the call was for them, and have rallied to the cause of watchfulness. Civic groups or veterans' groups—all sorts of organizations and their committees and their auxiliaries have assumed the solemn duties of the judging and screening of art. Crusades have developed in a number of places with some work of art as their subject. A mural in the process of execution in a federal building just barely survived a campaign to have it removed because it contained a portrait of Roosevelt. Another just barely survived because someone thought it failed to express American ideals. On a sail in a painting of a regatta a city councilman professed to have discovered a Communist symbol, and he sought to close the exhibition of which the painting was a part. (The symbol turned out to be that of a Los Angeles yachting club.) Another large painting was vetoed because it contained nudes.

The most recent of the civic crusades—to my knowledge—was directed against a very large exhibition of sports themes, paintings, drawings, and prints which had been laboriously assembled by *Sports Illustrated* with the assistance of the American Federation of Arts, and was to have been displayed in Australia at the time of last summer's Olympic meet. The exhibition was circulated in a number of American cities before it was to be shipped abroad. It came to grief in Dallas, Texas. There a local patriotic group discovered among the exhibitors some names which had appeared under "The Extension of Remarks by Congressman Dondero." So

great was the Texas commotion (and probably so delicate the political balance there), that the exhibition was not sent on to Australia.

In such a climate all art becomes suspect. And while the paint-alone métier has itself come under considerable attack, it is on the whole a safer category to be in than is the more communicative kind of art. In paint alone there are at least no daring commitments to the future, no indiscretions, no irreverence toward relatively sacred individuals, or toward their manners, emblems, or favored slogans. The aesthetic of line, color, and form, like any other way of painting, may always grow in the hands of a gifted painter; but today it has become the norm and the model of conformity. Young artists complain that their galleries freely press them into working

in such a manner. Art departments in schools and colleges are literally minting art of the content-less kind. One department head claims that he sees no further necessity for forcing upon his students the hard archaic disciplines of academic study since they will abandon them anyway.

The daily reviews in the newspapers are a concatenation of like descriptions of this artist's circles, or that artist's squares, or a third artist's spirals. A few days ago a reviewer, casting about for fresh adjectives with which to describe an unbroken yellow canvas, suddenly broke off with the inspired words, "Since there's nothing to look at, there's nothing to say!"

Today's conformity is, more than anything else, the retreat from controversiality.

Tomorrow's art, if it is to be at all stirring, will no doubt be performed upon today's forbidden territory.

I remember a story that my father used to tell of a traveler in thirteenth-century France who met three men wheeling wheelbarrows. He asked in what work they were engaged and he received from them the following three answers: the first said, "I toil from sunup to sundown and all I receive for my pains is a few francs a day." The second said, "I am glad enough to wheel this wheelbarrow for I have been out of work for many months and I have a family to support." The third said, "I am building Chartres Cathedral."

I always feel that the committees and the tribunals and the civic groups and their auxiliaries harbor no misgivings about the men who wheel their wheelbarrows for however many francs a day; the object of their suspicions seems, inevitably, to be the man who is building Chartres Cathedral.

Modern Evaluations

I have listened in on the pros and cons concerning a comment made by a speaker on art not very long ago—perhaps from this platform, I don't know.

Toward the end of a long question period, the speaker was asked to give some sort of comparative estimate of the work of Picasso as against that of Dali. Being tired, he replied, "Oh, the answer is very simple. Picasso *is* an artist and Dali is *not*."

The answer has a nice, clear, factual sound. But of course it is not factual; it is an evaluation. The answer implies that there is some fundamental basis of value in art by which a work may be objectively evaluated, and that Dali fails to meet its requirements.

Now, one may be justified in asking what fundamental value it is that Picasso meets but Dali doesn't. On what basis does the speaker reject Dali?

There is an undeniable vulgarity about the publicity-seeking stunts of Dali. But one doubts that the mere fact of his having once leaped through Bonwit Teller's window could be construed to have any bearing upon the quality of his paintings. Or could it? Besides,

one could not say with any degree of assurance that Picasso is totally free of venality, or that he shows a marked distaste for public relations.

No, our basis of evaluation must lie somewhere else.

Can we say then, that the work of Picasso has better content than that of Dali, or better forms, or that Picasso is a more competent painter, or that his own values are better ones than those of Dali? Again, no. For none of these qualities is an absolute in the light of which we can say that one thing is better or another worse. Picasso and Dali are equally competent exponents of extremely different kinds of value.

What then has constituted the criterion of judgment upon which our speaker has accepted Picasso and rejected Dali?

One might ask whether the basis of value is just the general acceptance of Picasso within highly informed art circles, and the increasing rejection of Dali. Does Picasso represent hard money, artistically speaking, and Dali soft? Is Picasso a secure art value and Dali a less secure one?

In the case of our particular speaker one may safely assume that he would not be swayed by the mere fact of popularity—even popularity within a small advanced circle. As an opinion-maker himself, one who constantly judges and appraises art, he is rather the individual who leads popularity than the one who follows it.

Is it a likelihood, then, that the broad vigorous quality of Picasso's work, his omnivorous mind, and his exploits into so many aspects of past cultures have themselves created a kind of basis for all contemporary judgments in art?

To that question, I think we must answer yes. Picasso, in his great variety and vigor of output, has provided the stimulus—however remotely—to almost the whole major art activity within the contemporary styles. Inevitably he has supplied an enormous portion of those values by which modern criticism evaluates art.

But such values are by no means finalities. Picasso has indeed

created a magnificent new world of forms. For those who apprehend them, a new dimension arises in the visual world, and forms emerge and become tangible that would not otherwise be perceived; perhaps the world expands or becomes more amusing. Such experience constitutes value, the kind of value that art conveys so well. Picasso has revitalized myth in his art, has captured the pagan

spirit and the primitive spirit, has explored everywhere and found and *created* value. But it is the function of such value to extend our consciousness, not to narrow it. The jejune world of Dali contains another sort of consciousness; we may reject its values in themselves, but should not bring alien principles into our judgments.

Then what are our values? Our values are presumably those things which we hold most dear. They are those matters which call forth our most enthusiastic participation (baseball, philosophy, skiing, music), or those things toward which we are most compassionate (children, stray cats, the small businessman), or those beliefs in the light of which we behave this way or that (religion, or being a Democrat), accepting some situations, strongly rejecting others. Or, for those who have sought to exile the emotions from their judgments, value may be constituted by those things which they hold most important (Defense, the size of the universe, or the preservation of national shrines).

Such a recognition of importance, however, of first things first, be it ever so logical, is not without its emotional involvement. We may note that the more important any matter may seem the more pressing it becomes emotionally.

But since it is pretty generally conceded that important matters should not be evaluated emotionally, the effort is made by a good many people to meet them with objectivity, which is, of course, a value of the highest order. Indeed, I have certain friends who manifest a perfect passion for objectivity.

One of them is a very able young physicist with whom I carry on a sort of running duel on the subject of values and particularly those of art. My friend likes his universe well-ordered. His own particular universe is one composed of measurable quantities which behave according to laws. To understand these laws, to analyze, or to predict constitutes for him the perfect intellectual exercise. He characterizes his field by the word "pure."

Art he regards as wholly emotional, irrational, and anything but

pure; it obeys no laws. Whenever I have asked him just where the intellect leaves off and the emotions begin, I have received an unclear answer. But roughly it appears that the emotions are a little brutish and underdeveloped and seem to be located in an inferior position physically, while the intellect is on a higher plane and tends to be more civilized.

I cannot pronounce upon the scientific accuracy of such a dividing of the emotions and the intellect. Nor can I conceive of an intellectual experience without its emotional dimension—without its degree of tenseness, its surge of excitement, its urgency, its pleasure of discovery, its satisfaction and subsequent relaxation. I would find it equally difficult to conjure up an abstract emotion—an emotion without its specific coloration of image and idea, without its thousand references, its complex of beliefs and hopes, its intentions frustrated or fulfilled, its causes fancied or real. Is such a separation possible?

Whatever his tendency to classify, my young friend has made a sincere effort to understand art. He has looked at paintings, sculpture, prints, searchingly and honestly. I doubt that he has had a wide or highly varied experience with art; he has, rather, looked mainly at those works which he has been told are worthy. And he has found himself unable to sympathize with or to comprehend what he has seen.

In our conversations my friend returns constantly to one problem; that is the measurements of value. He appears to seek a tangible, I might even say a quantitative, basis upon which, objectively, a piece of work may be pronounced good or bad. I haven't been able to help him much in this quest.

My own standards and ways of evaluating are constantly changing. I think I can tell competence from incompetence, but then there are so many kinds of painting in which competence is not actually the basis for evaluation. Children's paintings have usually no competence, but then they do have value; it seems to lie in a certain

96

kind of innocence, charm, sometimes in the revelation of surprising states of mind. The work of primitive painters is sometimes perfectly delightful for the very reason that its earnestness so outreaches its competence. And then there are two or three wings of very sophisticated contemporary painting which sedulously avoid competence and look upon it as a negative value. Surely we cannot bring a standard of competence into the evaluation of such art as this!

Not only my physicist friend but, I think, the public itself—at least that part of it that is interested in art at all—is involved in such a search for standards. How is the viewer of art to know what to look at seriously; how shall he evaluate what he sees?

We turn to the critic, to the historian, to the scholar, to the aesthetician, in other words, to the expert, hoping that he will provide us with some basis of appreciation, some true set of values for art.

Let us say that our particular scholar is a specialist in the Byzantine with its rigorous verticality, its splendid flashing of gold and rich colors, its intricate and highly formalized ornamentation. A man so trained may feel very honestly that the lumpy shapes of a Brueghel or the soft outlines of a Titian are hardly art at all. He misses that kind of brilliance which he knows so well. His values have risen from his experience and his enthusiasm; they are based upon intensive study of the kind of discipline that has produced one order of art, but which has little pertinence to other orders.

There is a much more than intellectual affinity in the scholar for the subject of his scholarship. There is necessarily a tremendous emotional involvement (indeed, if there were not I think that his studies would be less fruitful). And I feel sure that a great deal of the value which he discovers in his particular field must seem to possess some degree of finality, of absoluteness. Dismissing a certain order of art, or the work of some artist, he must feel that he is pronouncing a wholly objective judgment. But his judgment is al-

97

most necessarily a conditioned one. Scholarly dismissal of art may be well-founded; it may on the other hand merely lay bare an area of unacquaintance, ignorance, or failure to penetrate and to understand.

Critics, both those of scholarly status and those of the daily press, are also people of all sorts of emotional involvement—indeed, who is not? Sometimes unaccountably and sometimes with good sense they develop a warm attachment for some special trend in art or for the work of a single artist. By the same route they often develop intense hostilities, sometimes rationally founded and sometimes irrationally.

I know that it is often the earnest effort of critics to bring to painting and sculpture the most objective sort of consideration and judgment. But there is an underlying contradiction in this good purpose. Let us face it honestly: to have no values, no preferences, no enthusiasms would be simply to react to no art and to enjoy none. The critic with no values would be about as useful as the editorial writer with no opinions. For the moment let us say of the critic or other expert that his views about art may be pertinent but are not final.

(To criticize criticism is the irresistible sport of artists; and my own biased view toward criticism is that if it is good reading I can read it, and otherwise I cannot.)

I think that a very proper question at this point would be one inquiring whether there are not certain constants in art, certain factors present in all or most works on the basis of which they may be pronounced good or bad, successful or unsuccessful. Of course there are such constant factors. Scholars have recognized them and pointed them out. Artists sometimes strive for them, sometimes ignore them. The public may be sensitive to these constant qualities in art, unless it is indifferent to art altogether. Such factors become values or bases of judgment only in the light of prevailing beliefs and habits of mind. That which is a high point of value in one

civilization may be regarded as a violation of decency in another. (In Turkey, where modesty dictates the veiling of the feminine face, the rest of the torso may be only casually covered, and the feet may be bare. In Boston where it is assumed that the torso will be covered, no lady would appear on the street with her feet bare.)

I mentioned the verticality, the upward sweep, the formalism of Byzantine art. Those qualities were constant in it and were no doubt looked upon as having religious value. But, to the artists and the art historians of the Renaissance, that very verticality was looked upon as an awkward rigidity. Indeed it has been only within relatively recent times that we have returned to an appreciation of Byzantine art, and that we have been able to assimilate its value.

Such prevailing values exercise a powerful effect upon art, both in the making and in the judging. Consider, for instance, our own highly cherished concept of freedom. It is our proudest value, the one for which we are ready to sacrifice everything, so that we find ourselves inclined to sacrifice liberty of speech and even liberties of action—lest we be even suspected of opposing freedom. The concept of freedom in art takes interesting forms: freedom of execution, for instance, is a basis for evaluation. How often do we read the critical comment that this or that work appears "labored." And on the other hand, the calligraphic, the easily brushed style is highly admired; it has a free look about it. Extreme care is "tight" and not good; extreme freedom is "loose" and considered desirable. Art becomes increasingly free; it has freed itself of craft, freed itself from academic discipline, freed itself from meaning in many cases, and freed itself of responsibility. In some of the recent phases almost the only ingredient left in art besides paint seems to be freedom. To be "static" is negative, to be intellectual is negative, for both characteristics seem to inhibit the freedom of a work.

I would not even seek to exempt myself from this kind of evaluating. Like most Americans, I shrink from the thought of subservience of mind or person. I too cherish the word freedom. But I

want to be free to be painstaking if I want to, to be responsible, to be involved; to be free to exercise whatever intellect I may have, and I consider both discipline and craft indispensable to freedom.

Another of our sweeping contemporary evaluations is that of up-to-dateness. I forget just what woman it was who, somewhere near the turn of the century, said "better to be dead than to be out of style." Whoever it was certainly touched the keynote of the twentieth century, for the ideal of "the latest" is with us in force today. It is hardly necessary to point out the loss of status that goes with the outdated automobile, or the belief in the betterness of the newest model of television set, refrigerator, or other piece of equipment. Whether or not the new model is improved it must show a marked lateness of design in order to be desirable to the public.

But let us not sit in judgment on the general public for betraying such weaknesses; the more sophisticated circles are quite as strongly swayed by the new. The new off-Broadway play, the latest Japanese film, the most recent novel by Beckett—all derive a value from their newness that may have little bearing upon their quality. That which we call "good design" in furniture may or may not be good, but it has an exciting air of newness; it is modern. ("Never mind whether it is functional," said my cynical friend, "so long as it looks functional.")

And how about the pure objectivity of science? Does it not also show a slight tropism toward the new? The latest medical discovery seems to possess a certain potency that is absent from the discoveries of 1883 or 1912. The new ideas of physics breathe excitement; today the universe is found to be twice as old; tomorrow it expands four times in size; today the principle of parity is abolished; tomorrow it is re-admitted in a different framework. It is acknowledged that we, the public, cannot really know the meaning of these crashing reversals, but we are invited to share in their excitement.

"The latest" seems peculiarly ill-adapted to the evaluating of art, which derives so much of its honor from the old; but here too it has become a pressing value. That section of the public which is not even slightly entranced by plaid dinner jackets or chrome-laden cars will plunge spiritedly into conversation concerning the avant-garde in art. Wyndham Lewis, in a small book entitled *The Demon of Progress in the Arts*, has called this peculiar kind of evaluation in art "ahead-of-ism" and there is little that I can add to what he has said about it.

A work of art may rest its merits in traditional qualities; it may constitute a remarkable feat in craftsmanship; it may be a searching study into psychological states; it may be a hymn to nature; it may be a nostalgic glance backward; it may be any one of an infinite number of concepts, none of which may have any possible bearing

upon its degree of newness. And yet the compulsiveness of this value is demonstrated by the words of the painter who recently remarked to a critic, "Sometimes I feel like working like the old masters, but I can't." "No one," said he, "likes to be out of the swim of things."

Under such a necessity art can be pushed to meaningless extremes. And it is a constant struggle to wrench out of the paint tube something that is still newer than the new. Of course when such work becomes dated, its emptiness emerges, for nothing is so hard to look at as the stylish, out of style.

Another broad base of modern evaluations is science and technology, but particularly science. Our lives have been wholly recast by the new premises of science. It supplies a great content to modern philosophy, but it also supplies method and technique—perhaps beyond the implications of the subject matter. And I imagine that our contemporary devotion to the idea of objectivity is largely derived from science.

So we have begun to accord to scientific terms and phenomena an almost mystic potency. When we read of the quaint and ancient practice, as described by Cennino Cennini, of saying specific prayers for the mixing of specific colors and paints, we are charmed and amused. But we are not at all amused by the claims to scientific potency which run along the side of our toothpaste tube, or which herald the latest hormone cream for the arresting of old age. We perceive little humor in vitamin-enriched bread; we take the idea of personal travel to the moon as a matter of course; we carefully guide our automobile toward the nearest gasoline station that happens to advertise super-octane gas, although I doubt that many of us have the slightest notion of what super-octane is—I am sure that I haven't.

In our contemporary criticisms of art we are not unlikely to read of the time-space continuum as a property of the painting at hand; we come upon such terms as entropy and complementarity; and a

number of modes of painting take their names from biology or psychology. Still others take their cue from these sciences, and we have "automatic painting," "therapeutic painting," and the like.

I do not mean to imply that an interpretation of the sciences, or an evaluation or even a participation, is out of order in contemporary art; indeed I think all that is very much to the point. But at the moment I am speaking of the present tendency of art to borrow glory and to borrow value by a purely romantic self-association with scientific terminology. And one can imagine how ill fares that kind of painting, devoted to capturing the moods of nature or to some idea of craftsmanship, in the hands of those critics who are schooled in the terminology of Biomorphism, or Geometric Expressionism, or who look upon art as compulsive or unconsciously motivated.

The evaluations of cost and price and conspicious consumption apply to the enjoyment of art today quite as fully as they did during the Mauve Decade. Related to these is the ideal of achievement without effort. I myself have never known a painter or known of a painter whose career was not distinguished by prodigious labor, by the sacrifice of all advantages and personal welfare to the accomplishing of the work which he had in mind.

But the lot of the artist is supposed to be a jolly one; the art schools are inclined toward advising the young person just to "let the art happen." And biographers are prone to dwell upon the remarkable operation of genius and inspiration, rather than to attribute to their artist-subjects any such lowly procedure as that of work. Writers upon art are permitted to indulge themselves in a romanticism and, sometimes, a want of hard discipline that would spell death to art itself.

One further peculiarly modern evaluation is our abiding faith in know-how. During my few episodes of teaching, I have invariably been approached by a number of students for a private and man-to-man revelation of just what my peculiar formula for paint-

ing is. Just how are certain effects achieved? What is the secret, even the trick, by which forms are reduced to bear some unified appearance? By what formula is success to be achieved?

Such belief in know-how is not at all confined to students. I cannot list the number of occasions on which I have been asked to stand before some audience and make a painting so that they may watch the process from its beginning through all its ramifications to its completion. Such requests are based upon the assumption that, once the process is understood, the meaning of the painting

will be clear, and that the audience will thereafter possess the formula and know what to look for in painting.

If a painting is to be at all interesting, it is the very absence of formula that will help to make it so. If forms are reduced to have a certain common quality, a unity, that is so because they proceed from a personal vision, because they are affected and shaped by the aberrations or the excellences of a single mind. The personality is an axis which gives its radial direction to everything which issues from it.

Our national fears, too, affect the evaluations of art. Social Realism, for instance, tinged as it is with the official Soviet stamp, cannot be evaluated by critics according to its competence, nor be in any way dissociated from its political overtones.

One of the very recherché bases of evaluation but still one that dominates both the world of criticism and that of creative art is an inversion of the common standard of popularity. The reasoning goes something like this: public taste has often failed to understand very great art, has indeed violently rejected it. This very art, however, so often has been richly vindicated by time and subsequent tastes. Logically, then, it seems to follow that if a piece of work is truly great it will necessarily be rejected by the public. Here the inversion begins to emerge, for the belief has thus become universal among refined people that if a work of art is thoroughly incomprehensible to the public it must automatically be good. And out of that non-Aristotelian reasoning comes the following principle widely proclaimed by artists and by critics: the work of art must not appeal to the public, or be understood by it. "I hope," says one artist, "that I will never win public approval, for if I do I will know that my work is bad." "I tremble," says an eminent poet, "when I think of what will happen if the classics become available to the masses."

Like most artists I am deeply offended by the application of public approval as a standard for the evaluation of art. But I am cer-

tainly equally in disagreement with that curiously perverse stand-
ard of nonapproval. For however degraded the public intelligence
may have become through long-term, calculated efforts to pander
to it, or however spoiled the public eye, it is still the public itself
that is the reality of our culture. Here is the fertile soil in which to
sow your lilies. Here is the source of manifold instances for art, the
wellspring of emotions that are not warmed-over, and of unex-
pected, unique detail. We, as artists, may exist upon the fringe of
this reality or we may be an essential part of it; that is up to us.

But it is not the degree of communicability that constitutes the
value of art to the public. It is its basic intent and responsibility. A
work of art in which powerful compassion is innate, or which con-
tains extraordinary revelations concerning form, or manifests bril-
liant thinking, however difficult its language, will serve ultimately
to dignify that society in which it exists. By the same argument, a
work that is tawdry and calculating in intent is not made more
worthy by being easily understood. One does not judge an Einstein
equation by its communicability, but by its actual content and
meaning.

Value is communicated in works of art by means of symbols
which may be highly communicative or abstruse, and neither qual-
ity is an index of worth. Such symbols may be—on the most com-
pletely communicative level—only reproductions of existing things,
as are photographs. On the next level of obviousness, they may be
slightly selective, eliminating some unnecessary details. On a still
less obvious level the art symbols may be extreme simplifications,
a sort of short-hand, still representing objects but now requiring an
advanced ability on the part of the viewer to read or decipher. In
progressive degrees, reference to objects may give way to the
manner of representing them, to the look of the short-hand itself.
Thus we complete the transition from representational art to com-
pletely nonobjective art. First the object with no short-hand and
last the short-hand with no object.

Such considerations are formal; the understanding of them may be learned; even the most backward section of the public will ultimately catch up. Formal considerations do indeed constitute a part of the value of art; sometimes they constitute the whole meaning of the work. Formal considerations may be subjected to comparative measurements, and in cases in which skill or craft is an objective, we may bring to the work an evaluation of good or bad.

I have mentioned a number of those characteristically twentieth-century evaluations which we inevitably bring to the contemplation or enjoyment of a work of art. They are the fortuitous values; they may be within the work or they may be within the viewer. Such values are the passing vagaries of taste; they are sometimes the principles deduced by art historians, such as the authenticity of a work; or they may be concerned with the curious accumulation of money value, but they are not innate. Then there are the formal values, inseparable from the work, but sometimes amenable to objective or comparative evaluations.

The question, much argued, is whether there is innate value in the work of art, whether we may look for something deeper than those values which I have discussed, whether there are indeed constants in value which do not change with every viewer and which do not depend upon the viewer or rest solely in him. I feel that each work of art—each serious work—has an innate value. (Perhaps it is this quality that distinguishes art from other phenomena.) The work of art is the created image and symbol of a specific value; it was made to contain permanently something that was felt and thought and believed. It contains that feeling and nothing else. All other things have been excluded.

Most of us have looked at Edvard Munch's wonderful print called "The Cry." Until that image was made, a cry had been something else; it had never possessed just that value that Munch placed upon it. But the cry, there symbolized, will always remain just so, just the artist's unique intuition, just that emotion and that

value. The viewer may comprehend or may not comprehend, but the value remains crystallized in an image, available to those who are able to see.

How the individual viewer of art, or for that matter the public, may come to apprehend such value, it is difficult to suggest. I do not believe that there is any set of principles or rules that would open the doors of understanding. The values that reside in art are anarchic; they are every man's loves and hates and his moments of divine revelation. The apprehension of such values is intuitive, but it is not a built-in intuition, not something with which one is born. Intuition in art is actually the result of prolonged tuition. The so-called "innocent eye" does not exist. The eye at birth cannot perceive at all, and it is only through training that it learns to recognize what it sees. The popular eye is not *un*trained; it is only wrongly trained—trained by inferior and insincere visual representations.

I remember how violently and irrationally my own tastes in art shifted and changed as I was in the process of learning to become an artist. When I was about thirteen a cousin of mine decided to introduce me to a kind of art more desirable than I was learning as a lithographer's apprentice. She took me to the Metropolitan Museum to see an exhibition of the work of John Singer Sargent.

Privately I didn't care for the Sargents. They seemed wanting in the neatness and care which I was then striving to master. On leaving the exhibition, however, I came upon a small work which met completely all my ideals in art. It was, I found, by an artist named Taddeo Gaddi. I heard no more of this artist for many years, but his one small painting remained with me as my secret standard of excellence in art.

During my years at the National Academy of Design, I accepted without rebellion or doubts the standards which my teachers promulgated. These now became my absolutes, my external criteria for the evaluation of other people's work, my objectives in my own painting. Good drawing was a measurable value, as was truth to

nature, and beauty was the principle ingredient of painting although no one seemed to take the trouble to say just what beauty was. We seemed to follow, on the whole, the principles of the Venetian School. I myself produced the softened outlines, the always muted colors, and I strove for the aerial perspective which was one of the keynotes of the Neo-Venetian phase of the National Academy of Design.

It had not occurred to me to question the finality of Academy authority until an occasion arose on which I was asked to help hang an exhibition of paintings by Academy Greats. Carrying the works to and from the jurors, I was impressed and troubled by my own dissociation from anything that I saw among the pictures. There were the still lifes: the Buddha against a piece of Chinese drapery, the highlight flicked in smartly on its green-blue glaze; there were the barns, the hay-mows, the girl with wind-blown hair; there were the boats, fishing-smacks at Gloucester and other rocky coastal paradises that I had never seen. There were the cows knee-deep in water that always reflected some bit of purple distance.

I hadn't seen a cow since I had been a very small child in Russia. Could I ever paint such scenes? I thought not.

And was there no more to art?

My growing critical attitude was probably defensive. But it was also becoming fortified by constant visits to museums and by the reading of everything that I could find concerning art.

It is not necessary to trace here the numerous changes that my own taste or anyone else's undergoes in order to make the point that every new phase of taste has only one origin and that that is seeing. In Italy I found the Florentines and the Sienese, and found Taddeo Gaddi again; and this great discovery gave way to the ferment and the myriad finalities that were Paris. Each of these turns seemed real at the time, and vital. And, the truth is, I believe that they were so. For their values are not to be dismissed in the light of some super-value, some transcendent criterion according to

which temporal art values rise and fall. Their values rest in the profound attachments to their own criteria and their own goals.

If any single kind of value or evaluation has tended to survive the many tides and reversals of taste, belief, and dogma, I imagine *that* value consists in some vague striving for truth. The beliefs in what constitutes truth change with every generation, with each new great preacher or teacher or cataclysmic discovery or deep revelation through art or music or drama or poetry. Whatever our momentary concept of it may be, it seems as though truth itself is that objective which awakens the purest passion in man, which stimulates his mind and calls forth his heroic endeavors. It is in pursuit of truth perhaps that we are able to sacrifice present values and move on to new ones. And I am sure that it is most often in the light of what we believe to be truth that we criticize negatively or reject the values of others.

Of course the separate truths achieved are not final; they represent only the moments of enlightenment. I believe that it is such moments of enlightenment that are formulated and perhaps preserved in art. I believe that artists are always in pursuit of the ultimate according to their lights—the perfect religious emotion, the very fundamentals of form, or the underlying character of man.

The Education
of an Artist

I am going to begin this discussion with a brief outline of a course of education which I would recommend to a young person intending to become an artist. And then I will move on to some of the reasons for this somewhat unusual course of study.

One's education naturally begins at the cradle. But it may perfectly well begin at a later time too. Be born poor . . . or be born rich . . . it really doesn't matter. Art is only amplified by such diversity. Young people of both origins may or may not become marvelous artists. That depends upon factors having little to do with circumstances of birth. Whether they will become significant artists seems to depend upon a curious combination of biology and education working upon each other in a fashion too subtle for the eye to follow.

But there is a certain minimum program. There are, roughly, about three conditions that seem to be basic in the artist's equip-

ment: to be cultured, to be educated, and to be integrated. Now let me be the first to admit that my choice of terms is arbitrary; many words could be substituted and mean approximately the same thing. This odd choice of terms, however, has a reason which will perhaps emerge as I proceed.

Begin to draw as early in life as possible. If you begin quite early, use any convenient tool and draw upon any smooth uncluttered surfaces. The flyleaves of books are excellent, although margins of text-books too have their special uses, as for small pictorial notations upon matters discussed in classes, or for other things left unsaid.

My capsule recommendation for a course of education is as follows:

Attend a university if you possibly can. There is no content of knowledge that is not pertinent to the work you will want to do. But before you attend a university work at something for a while. Do anything. Get a job in a potato field; or work as a grease-monkey in an auto repair shop. But if you do work in a field do not fail to observe the look and the feel of earth and of all things that you handle—yes, even potatoes! Or, in the auto shop, the smell of oil and grease and burning rubber. Paint of course, but if you have to lay aside painting for a time, continue to draw. Listen well to all conversations and be instructed by them and take all seriousness seriously. Never look down upon anything or anyone as not worthy of notice. In college or out of college, read. And form opinions! Read Sophocles and Euripides and Dante and Proust. Read everything that you can find about art except the reviews. Read the Bible; read Hume; read Pogo. Read all kinds of poetry and know many poets and many artists. Go to an art school, or two, or three, or take art courses at night if necessary. And paint and paint and draw and draw. Know all that you can, both curricular and noncurricular—mathematics and physics and economics, logic, and particularly history. Know at least two languages besides your own, but anyway, know French. Look at pictures and more pictures. Look at every kind of visual symbol, every kind of emblem; do not spurn signboards or furniture drawings or this style of art or that style of art. Do not be afraid to like paintings honestly or to dislike them honestly, but if you do dislike them retain an open mind. Do not dismiss any school of art, not the Pre-Raphaelites nor the Hudson River School nor the German Genre painters. Talk and talk and sit at cafés, and listen to everything, to Brahms, to Brubeck, to the Italian hour on the radio. Listen to preachers in small town churches and in big city churches. Listen to politicians in New England town

meetings and to rabble-rousers in Alabama. Even draw them. And remember that you are trying to learn to think what you want to think, that you are trying to co-ordinate mind and hand and eye. Go to all sorts of museums and galleries and to the studios of artists. Go to Paris and Madrid and Rome and Ravenna and Padua. Stand alone in Sainte Chapelle, in the Sistine Chapel, in the Church of the Carmine in Florence. Draw and draw and paint and learn to work in many media; try lithography and aquatint and silk-screen. Know all that you can about art, and by all means have opinions. Never be afraid to become embroiled in art or life or politics; never be afraid to learn to draw or paint better than you already do; and never be afraid to undertake any kind of art at all, however exalted or however common, but do it with distinction.

Anyone may observe that such an art education has no beginning and no end and that almost any other comparable set of experiences might be substituted for those mentioned, without loss. Such an education has, however, a certain structure which is dictated by the special needs of art.

I have been curious and have inquired from time to time about the objectives toward which the liberal education is pointed. I have been answered in different ways—one that it hopes to produce the cultured citizen, or some hold that it simply wants its graduates to be informed—knowledgeable. And I think that the present ideal is to produce the integrated person. I myself can see no great divergence between these objectives and the ones necessary to art.

I think we could safely say that perceptiveness is the outstanding quality of the cultured man or woman. Perceptiveness is an awareness of things and people, of their qualities. It is recognition of values, perhaps arising from long familiarity with things of value, with art and music and other creative things, or perhaps proceeding from an inborn sensitiveness of character. But the capacity to value and to perceive are inseparable from the cultured person. These are

indispensable qualities for the artist too, almost as necessary as are his eyes—*to look and look, and think, and listen, and be aware.*

Education itself might be looked upon as mainly the assimilation of experience. The content of education is naturally not confined to the limits of the college curriculum; all experience is its proper content. But the ideal of the liberal education is that such content be ordered and disciplined. It is not only content, but method too, the bridge to further content. I feel that this kind of discipline is a powerful factor in any kind of creative process; it affords the creative mind means for reaching into new fields of meaning and for interpreting them with some authority. The artist or novelist or poet adds to the factual data the human element of value. I believe that there is no kind of experience which has not its potential visual dimension or its latent meanings for literary or other expression. *Know all you can—mathematics, physics, economics, and particularly history.* As part of the whole education, the teaching of the university is therefore of profoundest value.

But that is not to dismiss self-education as an impressive possibility, and one illuminated by a number of the greatest names in literature, art, and a good many other fields, not excluding the sciences. There is no rule, no current, about self-education any more than there is about advantages or disadvantages of birth. It is historically true that an impressive number of self-educated individuals have also been brilliantly educated: widely read, traveled, cultured, and thoroughly knowledgeable, not to mention productive. The dramatist who has had perhaps the greatest influence upon the contemporary theater stopped school at the age of thirteen. The painter who has set world taste in art is almost entirely self-educated. That does not mean *un*educated, for each of these two people is almost unmatched in versatility of knowledge.

And that brings us to the third item in our minimum program for the education of an artist: to be integrated. (My sixteen-year-old daughter takes issue with this term. Whatever she may be she does

not want to be "integrated." Perhaps I can persuade her.)

Being integrated, in the dictionary sense, means being unified. I think of it as being a little more dynamic—educationally, for instance, being organically interacting. In either sense, integration implies involvement of the whole person, not just selected parts of him; integration, for instance, of kinds of knowledge (history comes to life in the art of any period); integration of knowledge with thinking—and that means holding opinions; and then integration within the whole personality—and that implies holding some

unified philosophical view, an attitude toward life. And then there must be the uniting of this personality, this view, with the creative capacities of the person so that his acts and his works and his thinking and his knowledge will be a unity. Such a state of being, curiously enough, invokes the word *integrity* in its basic sense: being unified, being integrated.

In their ideal of producing the person of integrity—the fully integrated person—colleges and universities are somewhat hampered by the very richness and diversity of the knowledge content which they must communicate. Development of creative talents is allowed to wait upon the acquisition of knowledge. Opinion is allowed to wait upon authority. There may be certain fields in which this is a valid procedure, but it is not so in art. (*Draw and draw, and paint, and learn to work in many media.*)

Integration, for the person in any of the creative arts, might be said to be the organic relating of the thousand items of experience into form, for the poet, into tonalities and cadences and words with their many allusive senses and suggested images. The thinking of the poet must habitually be tonality and cadence thinking, as with the artist it is color, shape, image thinking. In each of these cases the discipline of formulation is inseparable from the discipline of thinking itself.

I hope that I have not too badly stretched these commonly used terms, to be cultured, to be educated, to be integrated. In any case, in the sense in which I have used them they are and have been the basic equipment of artists.

I sometimes find myself viewing with great nostalgia the educational procedure by which such artists as Leonardo were initiated into art. When the young man of the Quattrocento decided to pursue a career of art, he simply put together his most impressive pieces of work, showed them to a number of people and ultimately became apprenticed to one of the known Masters. There he began his service and education by grinding colors and mixing them, by

117

preparing surfaces, and probably even making brushes. (What a fundamental kind of training that seems to us today when so many of us do not even know what our paints are made of!) The young artist probably was permitted first to paint in backgrounds. He was no doubt advanced in time to skies and landscapes, draperies, a face or so, and ultimately matriculated into angels. As he learned the use of his hands, and how to see things in shapes and colors, other changes were taking place in him. Perhaps his rustic manners were becoming a little more polished so that he could take part in the conversations of the atelier, even venture an opinion or so. He gradually became acquainted with the larger problems of the painter: composition, construction, qualities of spirituality or beauty, meaning in pictures. There was constant talk about art, about form; and there were the great artists who came in and out of the atelier (those who were on speaking terms with his employer). The young painter gradually mastered iconographies, Christian and pagan and personal.

But then there was music too, and poetry read and discussed, and the young artist not infrequently became both musician and poet. There was the conversation of learned men, talk of science, the excitement in the revival of ancient learning, mastery of the humanities. Of course there were the new buildings, too, palaces and fountains, and always the interest in the great spaces to be filled by paintings, the open courts to be occupied by sculpture, the façades and domes and bridges to be ornamented with beautiful shapes.

The day came, of course—the famous day—when the young painter executed a foreground with an angel which far surpassed in beauty the work of the Master. Then of course he was very much in demand, the master of his own atelier.

How integrated indeed was the growing artist of that time, and cultured, and educated!

There have been efforts to revive the apprenticeship system, but not very successful ones. I believe that if such a revival ever is ac-

complished it will be preceded by integration of a different sort from that which I have been talking about—by the integration of art itself into the common life of the nation, as it was so integrated during the Renaissance in Italy. Since there is such rising interest in the setting and the look of the new great buildings—not just in their size, but also in their beauty and their placement—it seems not im-

possible that there may take place a resurgence of art upon a vast scale, of mural painting and mosaics, great out-of-door sculpture, and the ornamentation of public places.

The artist of the Renaissance had no great problems of style comparable to those which plague the young artist of today. He might simply follow the established manners of painting as most artists did. If his powers were greater or his vision more personal he expanded the existing manners of painting to meet his needs. But the artist today, and particularly the young one, feels challenged to be unique.

Such a condition, such a challenge, strikes at the security of the painter; it may sometimes press artists to exceed the bounds of good sense, simply to be different. But such a challenge has much to do with the character and the function of today's art, and despite its hazards it is also an advantage and an opportunity.

It is in the nature of today's art to draw upon the individualness of the painter and to affirm the individualness of perception in the audience or viewer of art. The values of art rest in the value of the person. Art today may be as deeply subjective as it is possible for man to be, or it is free to be objective and observant; it may and it does examine every possible human mood. It communicates directly without asking approval of any authority. Its values are not those of set virtues, but are of the essential nature of man, good or bad. Art is one of the few media of expression which still remains un-edited, unprocessed, and undictated. If its hazards are great, so are its potentialities magnificent.

It seems to me that this particular function of art—to express man in his individualness and his variety—is one that will not easily run out. It may have its low points, but the challenge and the potentiality remain high. The accomplishments of modern art in this individualistic direction are already impressive, of course. There have been quite remarkable psychological probings and revelations in painting; there are a dozen or so schools which one might mention

—the Surrealists, the German Expressionists, and so on. There have been the sociological efforts—Social Realism and some others. The poetic sense has been brilliantly exploited—Loren MacIver and Morris Graves and so many contemporary artists. We have the love of crumbling ruins in one painter, Berman, the return to myth in others, many others. Art has probed the mysteries of life and death, and examined all the passions. It has been responsible and irresponsible, and sympathetic and satiric. It has explored ugliness and beauty and has often deliberately confused them—much to the perplexity of an often lagging public. (*Listen to Brahms and Brubeck and the Italian hour on the radio.*)

All such probing and testing of reality and creating of new realities may result from different kinds of educational focus, different kinds of content, but they always require the three basic capacities: first, of perceptiveness, a recognition of values, a certain kind of culture, second, a capacity for the vast accumulation of knowledge, and third, a capacity to integrate all this material into creative acts and images. The future of art assuredly rests in education—not just one kind of education but many kinds.

During the past decade I have taken part in a great number of art-oriented symposiums, the general object of which seems to be educational. Since the telltale traces remain in my file cabinet, I have scanned some of the titles just to be refreshed upon what the main problems are that perplex the young, and that concern the art-interested public.

Titles set forth for the artists, architects, museum directors, and the like to discuss read like so many sermons. "Modern Art and Modern Civilization," "If I Had My Art Career to Begin Today," "Artistic Creation in America Today," "Creative Art During the Next Twenty-Five Years," "Creative Art During the Past Fifty Years," "The Artist's Credo," "Relation of Morals to Art," "How Can the Artist Contribute to an Industrial and Scientific Age?" (I think I told them that it couldn't), "Why Does the Artist Paint?"

(Why, indeed!), "Responsibility for Standards of Taste in a Democratic Society," "The Search for New Standards" (Aren't we standardized enough?), and then three or four such discussions devoted to the education of the professional artist.

When all the questions have been asked and all the opinions are in, there seem to be about three major problems which concern the young artist, not lofty ones, but rather earthly and practical. They are simply: "What shall I paint?" "How shall I paint it?" and "What security can I have as a painter?" It seems pertinent to this discussion to consider these questions.

As to the first—"What shall I paint?"—the answer is a pretty obvious one, "Paint what you are, paint what you believe, paint what you feel." But to go a little deeper, such a question seems to indicate an absence of opinion, or perhaps it indicates a belief, not an uncommon one, that painting ought to be this or ought to be that, that there is some preferred list of appropriate subjects. Again I think that many young people if they were asked "What do you believe, or hold most dear?" would reply honestly, "I do not know." And so we again go back to our first outline for an education: *"In college or out of college, read, and form opinions."*

In the absence of very strong motives and opinions, the solution arrived at by the student or young artist who does not know what to paint is that he simply copies or produces a replica of what some other artist has painted before. Ultimately, however, even in this process there seems to take place a kind of self-recognition—if the young person continues to paint at all. He finds certain elements among his eclectic choices which are expressive and meaningful to him. Gradually his own personality emerges; he develops beliefs and opinions. One might say, through his own somewhat stumbling creative efforts he gradually becomes an integrated person.

The second question—"How shall I paint?"—is a stylistic one and is not unrelated to the foregoing content question. Again there is the suggestion of an absence of opinions and values—beliefs.

Some years ago when the painter Max Beckmann died suddenly, I was asked to take over his class at the Brooklyn Museum School. I did so . . . reluctantly. On my first morning with the students I looked over their work and it appeared to me that the most conspicuous fault in it was a lack of thinking. There seemed to be no imaginative variety or resourcefulness. It was mostly just Beckmann. I certainly was not going to go on teaching more Beckmann however greatly I may admire his work—and I do. I remember sitting on the edge of the model stand to have a sort of exploratory talk with the students. It seemed to me desirable to uncover some long-range objective, if there was any, and to find out what sort of people they were. We talked about all sorts of things, and I probably talked quite a little—I usually do.

In the midst of our discussion one of the students walked up to me and said, "Mr. Shahn, I didn't come here to learn philosophy. I just want to learn *how* to paint." I asked him which one of the one hundred and forty styles he wanted to learn, and we began to establish, roughly, a sort of understanding.

I could teach him the mixing of colors, certainly, or how to manipulate oils or tempera or water color. But I certainly could not teach him any style of painting—at least I wasn't going to. Style today is the shape of one's specific meanings. It is developed with an aesthetic view and a set of intentions. It is not the how of painting but the why. To imitate or to teach style alone would be a little like teaching a tone of voice or a personality.

Craft itself, once an inexorable standard in art, is today an artist's individual responsibility. Craft probably still does involve deftness of touch, ease of execution—in other words, mastery. But it is the mastery of one's personal means. And while it would be hard to imagine any serious practitioner in art *not* seeking craft and mastery and deftness, still it is to be emphasized that such mastery is today not measured by a set, established style, but only by a private sense of perfection. (*Paint and paint, and draw and draw.*)

I have mentioned our great American passion for freedom. And now, let me add to that the comment that freedom itself is a disciplined thing. Craft is that discipline which frees the spirit; and style is the result.

I think of dancers upon a stage. Some will have perfected their

craft to a higher degree than others. Those who appear relatively more hampered and leaden in their movements are those of lesser craft. Those who appear unimpeded, completely free in all their movements, are so because they have brought craft to such a degree of perfection. The perceptive eye may discern the craft in many varieties of art. The nonperceptive eye probably seeks to impose one standard of craft upon all kinds of art.

Last year I visited the painter Morandi in Bologna. He expressed to me his sympathy with the young art students of the present day. "There are so many possible ways to paint," he said, "it's all so confusing for them. There is no central craft which they can learn, as you or I could once learn a craft."

The third question which emerges from our symposiums is that concerning how the artist is to earn his living in art. Well, I shall not pretend to be able to answer that. Some artists manage to live by their art alone. Some do commercial work, some teach, some do completely unrelated work in order to support their art. And there are many kinds of professions associated with art—editorial work, designing, and so on. But they have no bearing upon the possible education of an artist.

But some of these problems of living are at least revealing. One young man has told me that he fears the insecurity of art. A second has confessed that he wants to live graciously—and there is certainly nothing wrong with that. A third young man feels that art is actually not a profession in the sense in which the law or medicine are professions. "As an artist," he says, "you cannot hang out a shingle and be in business. You may finish a number of years of study and still not have the means to a livelihood."

No one can promise success to an intended painter. Nor is the problem of painting one of success at all. It is rather one of how much emphasis one places upon self-realization, upon the things that he thinks. I believe that the individual whose interests are measurable primarily in terms of money, or even of success, would

do well to avoid a lifetime of painting. The primary concern of the serious artist is to get the thing said—and wonderfully well. His values are wholly vested in the object which he has been creating. Recognition is the wine of his repast, but its substance is the accomplishment of the work itself.

There are many kinds of security, and one kind lies in the knowledge that one is dedicating his hours and days to doing the things that he considers most important. Such a way of spending one's time may be looked upon by some as a luxury and by others as a necessity. It may be security and it may be gracious living. (*Go to Paris and Rome and Ravenna and Padua, and stand alone in Sainte Chapelle.*) (*Talk and talk and sit at cafés, and listen . . . and never be afraid to become embroiled . . .*)

As to its degree of professionalism, art is I suppose as professional as one makes it. Some painters work very methodically, observing an eight- or more-hour day, dispensing their work through galleries, placing pictures in every current exhibition, and having representatives in many parts of the country. Others are very haphazard about all this detail, and paint when the mood strikes them. But I suppose that almost any artist today whose major occupation is art has some more or less business-like connection with a practical world through one or another kind of agency or individual. Perhaps it is not customary to hang out a shingle as the lawyer is supposed to do, but it might be an interesting experiment.

Besides these questions of what to paint and how to paint and the one which I cannot attempt to answer—how to live—there is a further question which I often ask myself. That is, for whom does one paint?

Oh yes, for oneself; that is obvious. The painter must fulfill his own personal needs and must meet his own private standards. But whom actually does he reach through his painting?

I suppose that the tangible public of any artist is confined to a circle of persons of like mind to himself, perhaps never a very large

circle. They are a rather special public: those who know art, who comprehend the formal means—the short-hand—of any particular painter, those who are in sympathy with his aims and views.

Then there is a wider, implied public, that which the artist himself deems fundamental, the people whom, ideally, he would like to reach, or whose realities are encompassed by his work. And then there is the whole public. However abstruse may be the forms of a work of art at the time of its creation, it seems as though ultimately the public does catch up, and does come to understand meanings. Looking backward, one might be justified in saying that if what any artist has to say is fundamentally human and profound the public will ultimately take his work unto itself. But if his own conceptions are limited and narrow in their human meaning it seems likely that time will erase his work.

Kandinsky views this process of the widening understanding of art as a sort of triangular one; the tip of the triangle always occupied by the originators, the innovators, whose work is little under-

stood. As the triangle of taste moves onward, an ever-widening public comes to understand it, until the base of the triangle is reached (or approximately the whole public) and the work is widely accepted. By this time, of course, new ideas and new ways of painting form the apex of a new triangle, unacceptable again to the major part of the public, but probably destined for its ultimate enjoyment and understanding.

The sense of reality and meaning in any person's life and his work is probably vested in a community of some sort wherein he finds recognition and affirmation of whatever he does. A community may, of course, be only the place in which someone lives; or a community may consist in a circle of admirers (such as that which I have mentioned above), or again it may be some area of self-identification, the place of one's birth, or some way of life that appeals to him. There is a considerable loss of the sense of community in present-day life. And I think that one of the great virtues of the university lies in its being a community in the fullest sense of the word, a place of residence, and at the same time one of personal affirmation and intellectual rapport.

The young artist-to-be in the university, while he may share so many of the intellectual interests of his associates, and has a community in that respect, is likely to be alone artistically. In that interest he is without community. And as a result he suffers keenly the absence of the sense of reality in art. Even though his choice of a life's work may meet with complete approval among his fellows, he still is without the give-and-take of well-informed, pointed, and experienced conversation pertinent to what he is doing. But then it is not at all unlikely that his ambitions may be looked upon by some of his friends as a sort of temporary derangement. Almost all the other young people around him will be turning their energies and conversations toward work of a seemingly more tangible order, toward professions or toward the business world.

אפ'ס י
אלא ספר

One's future intentions are intangible things at best; they have always some flavor of unreality. There are few college students who would presume to look upon themselves as presidential candidates or Nobel Prize winners. The writer who has not written or the painter who has not yet painted seems, even to himself perhaps, to be grasping at wisps of smoke or to be deluding himself with romance. For such a person, there are as yet no such certainties. Artistically speaking, he does not yet know who he is or will be. More than anyone else, the young person embarked upon such a career needs a community, needs its affirmation, its reality, its criticism and recognition. (Or, as I put it a little earlier in that highly compressed description of an artist's education: *Know many artists. Go to an art school, or two or three. Look at pictures and more pictures. Go to all sorts of museums and galleries and to the studio of artists.*)

In the case of an older artist, one who has done a great deal of painting, his own work may in a strange sort of way come to constitute for him a certain kind of community. There is some substance and affirmation in what he has already done. It at least exists; he has found that he can cast a shadow. In relation to what he has done the new effort is no longer an unreality or an uncertainty. However small his audience, he has some sense of community.

The public function of art has always been one of creating a community. That is not necessarily its intention, but it is its result —the religious community created by one phase of art; the peasant community created by another; the Bohemian community that we enter into through the work of Degas and Toulouse-Lautrec and Manet; the aristocratic English community of Gainsborough and Reynolds, and the English low-life community of Hogarth.

It is the images we hold in common, the characters of novels and plays, the great buildings, the complex pictorial images and their meanings, and the symbolized concepts, principles, and great ideas of philosophy and religion that have created the human com-

munity. The incidental items of reality remain without value or common recognition until they are symbolized, recreated, and imbued with value. The potato field and the auto repair shop remain without quality or awareness or the sense of community until they are turned into literature by a Faulkner or a Steinbeck or a Thomas Wolfe or into art by a Van Gogh.

704
Shahn

The shape of content

OCT